THE
Archive Photographs
SERIES

WANDSWORTH

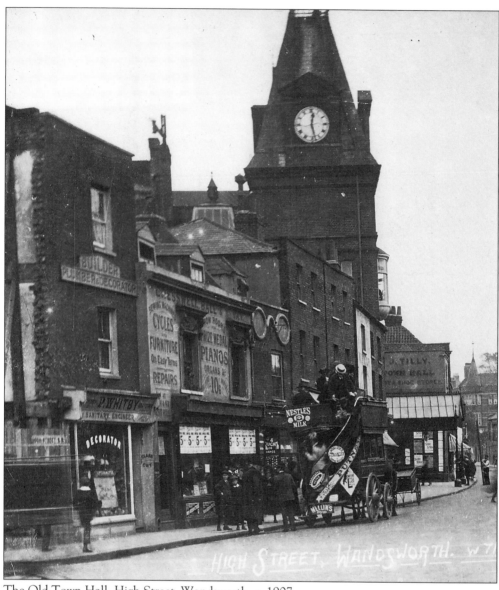

The Old Town Hall, High Street, Wandsworth, *c.* 1907.

THE
Archive Photographs
SERIES
WANDSWORTH

Compiled by
Patrick Loobey

**THE
CHALFORD
PRESS**

BATH • AUGUSTA • RENNES

First published 1994
Copyright © Patrick Loobey, 1994

The Chalford Press
12 Riverside Court
Bath BA2 3DZ

ISBN 0 7524 0026 6

Typesetting and origination by
The Chalford Press
Printed in Great Britain by
Redwood Books, Trowbridge

Contents

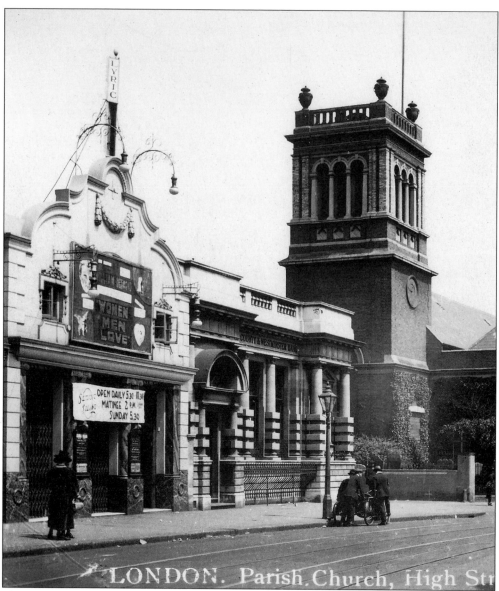

The parish church and the Lyric Cinema, *c.* 1925

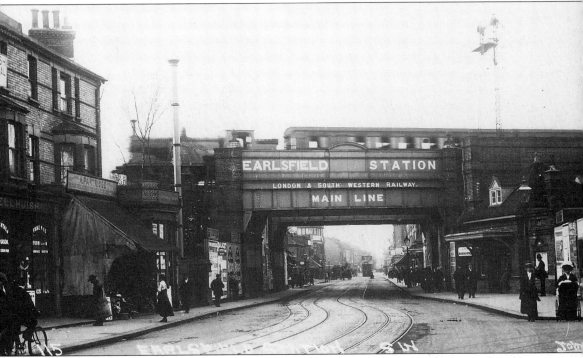

Earslfield Station, c. 1911.

Introduction

The scenes within these pages will, in part, explain the former industrial importance of Wandsworth. Many of the local population were employed by the gas works, the many mills on the river Wandle, the gas mantle manufacturers, and also in the public houses required in a town situated on an important route into London. Large eighteenth-century mansions gave way to the need in Victorian times for more housing and the medieval field pattern was covered with streets by such firms as the British Land Company. Many of our parks and institutions that are still valued and in use today were given as gifts to the people of Wandsworth by public-spirited local MPs and mayors. Both Southfields and Earlsfield were still farmland up to the First World War, that horrible conflict which started on a sunny bank holiday in August, in which many of the young delivery boys in some of these views would give their lives, sweeping away the youthful expectations of Edwardian Britain.

The district has altered dramatically since the 1970s, with riverside industries disappearing and their former sites covered with housing schemes. Constant changes in the fabric of the area can be seen throughout history and to this extent the author would be pleased to hear from any person with memories, anecdotes, photographs, or comments they wish to share regarding the scenes within these pages.

P.J. Loobey
231 Mitcham Lane
Streatham
London SW16 6PY

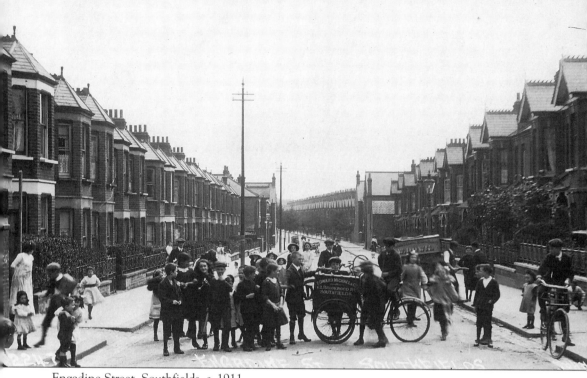

Engadine Street, Southfields, *c.* 1911

Born in 1947, Patrick Loobey has lived in Balham, Putney, Southfields, and Streatham—all within the Borough of Wandsworth. He joined Wandsworth Historical Society (founded 1953) in 1969 and has served on its archaeological, publishing, and management committees, being chairman of the society from 1991 to 1994. Having collected Edwardian postcards of Wandsworth Borough and the surrounding district for nineteen years, he has a wide ranging collection, encompassing many local roads and subjects.

Patrick privately published a volume of postcard views of Putney and Roehampton in 1988 and another on Battersea in 1990. Forthcoming titles will include Battersea and Clapham, and Putney.

Reproductions of all the views in this book are available from Patrick Loobey, 231 Mitcham Lane, Streatham, London, SW16 6PY (081-769 0072).

The captions to the photographs in this book are but a brief glimpse into the varied and complex history of the area. For those seeking further information, the Wandsworth Historical Society covers the borough's boundaries, publishing a journal and various papers, the fruits of members' research. Monthly meetings are held on the last Friday of each month at 8pm at the Friends' Meeting House, Wandsworth High Street.

The author must thank and recommend the Local History Library at Lavender Hill, Battersea, where early newspapers, deeds, directories, maps, and parish records are made available to those wishing to research names, dates, and addresses of families or business concerns.

Thanks must go to my wife, Joan Loobey, for her assistance.

One

East Hill

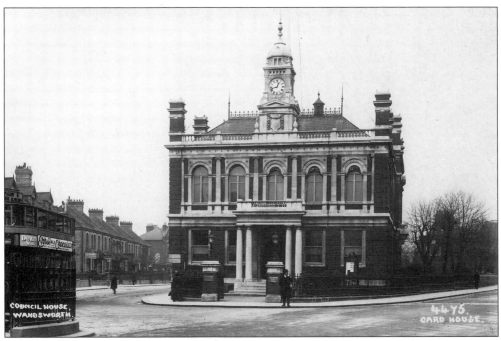

The Council House, East Hill, *c.* 1912. It was built for the Wandsworth District Board of Works by Messrs C. Kynoch & Co. of Clapham at a cost of £6,385 and it opened for use in 1888. Taken over by the newly-formed Borough Council and renamed Council House, it was used as municipal offices. It was sold to the County of London Electric Supply Co. in 1937 and renamed County House. They moved to Battersea in 1953, after which time several finance firms occupied the premises until 1980 when the Book Trust made it their headquarters. It now has the name Book House.

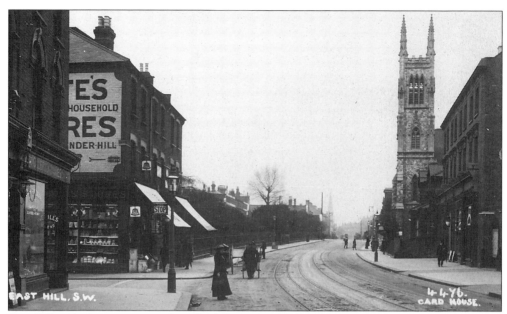

East Hill with Huntsmoor Road on the left, c. 1912. Harry Colbrook's dairy is on the left, with M.G. Bates Grocers on the next corner. The Wesleyan church was opened on 28 June 1865 with seating for 1,000 people. Meetings had previously been held in the assembly rooms of the Spread Eagle Public House. The site was purchased in 1864 for £400 with a further £319 16s 0d for the school alongside. Messrs Dove Brothers built the church and a Mr Tarring was the architect. John Wesley had preached in Wandsworth over a forty-two-year period commencing in 1748. The church was destroyed by a land mine in April 1941; the new building opened on 16 March 1957.

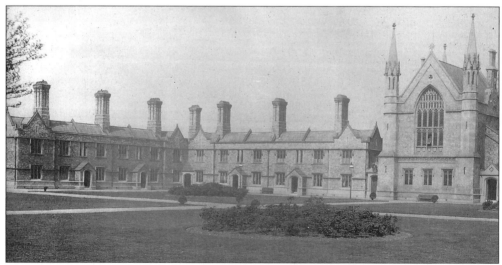

The Fishmongers' Almshouses, East Hill, c. 1906. The charity was founded at Newington in 1619. It sold off the land and moved to Wandsworth, and the foundation stone for the new St Peters Hospital was laid on 22 June 1849. The *Illustrated London News* dated 24 May 1851 stated that 'the position of the new hospital is as airy a spot as any in the environs of the Capital'. Demolished in 1923 for an LCC housing estate, it has since been replaced by a newer estate—the ornate gateway and pillars of the almshouses survive in isolation.

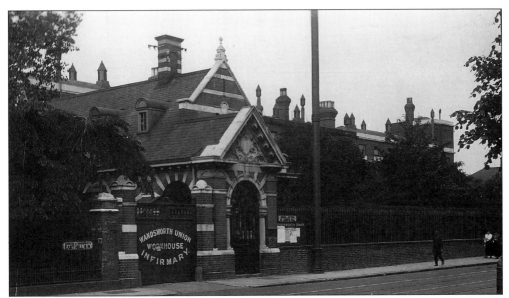

Wandsworth Infirmary and Workhouse, East Hill, *c.* 1912, which was opened in 1838 under the Poor Law Reform Act of 1834. In 1866 there were 523 inmates, of which 224 were on the medical officer's books with only two illiterate nurses administering the medicines. An earlier workhouse stood on East Hill, just above Tonsley Hill. The workhouse moved to Swaffield Road in 1886 and the building on East Hill remained as an infirmary only, named St John's Hospital. Part of the building survives and has now been converted into flats.

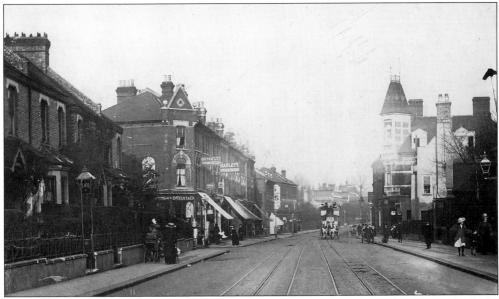

East Hill, at the junction with Birdhirst Road *c.* 1912. On the right is the Roman Catholic oratory of St Mary Magdalen, and beyond is the tower of the French Horn and Half Moon hotel and public house, frequently mentioned in the eighteenth century as a venue for the Parochial Council for Wandsworth. Woodwell Street, alongside, and the pub have since been demolished. A few doors beyond there used to be an LCC electricity booster sub-station for the tramway service.

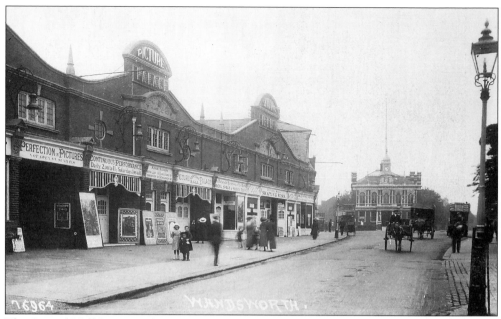

The Central Hall Picture Palace, *c.* 1912, which was built in 1909 as a picture house and roller skating rink plus billiards room. The rink was laid with deal, on which hockey was played. The complex did not open on Sundays. It closed in 1918 and was converted into shops.

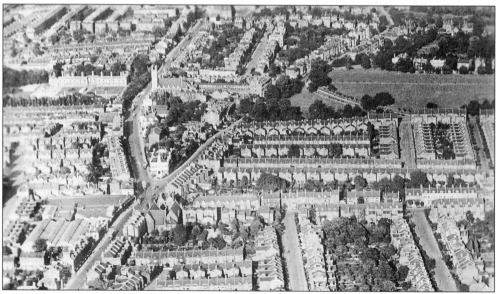

East Hill from the air, *c.* 1925. The Council House is prominent at the junction of East Hill and Huguenot Place. The common and Trinity Road lead off to the right, with Eglantine and Rosehill Roads leading from the lower right. The Central Hall picture house and G.N. Motors, later used by Clayton Minerals, can be seen on the lower left.

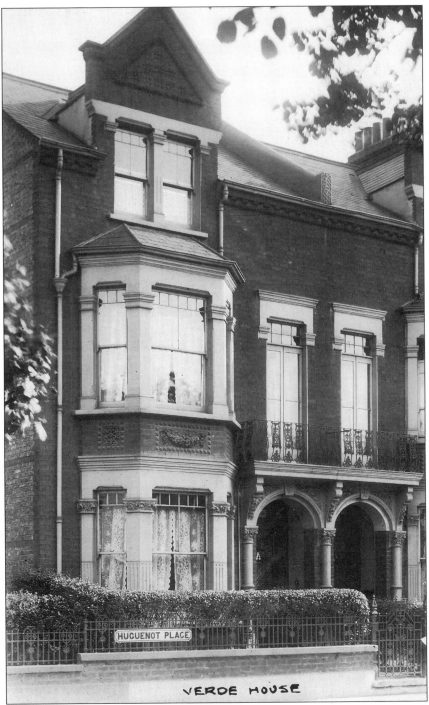

Huguenot Place, *c.* 1907. The name was approved in 1897 in honour of the many French Huguenots who settled in Wandsworth after the revocation of the Edict of Nantes on 17 October 1685. During the reign of Louis XIV, approximately 50,000 French protestants fled to England. They brought many industries to Wandsworth, among which was the making of hats. Many of the cardinals in Rome ordered their hats from these Wandsworth families.

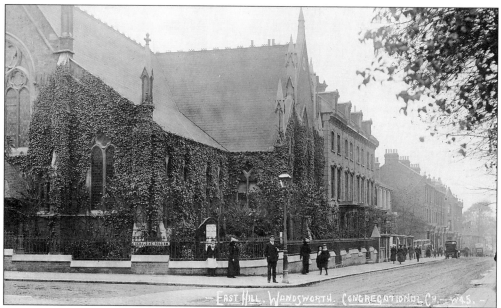

The Congregational church, East Hill, c. 1907. Situated on the corner of Geraldine Road, the church's foundation stone was laid on 9 October 1875 by the pastor, James D. Bloomfield, and Mr George Williams. The older chapel, in the High Street, was first used in 1573. The Large Hall alongside the church in Geraldine Road was erected in 1881, the foundation stone having been laid by Mr James Curtis on 29 June.

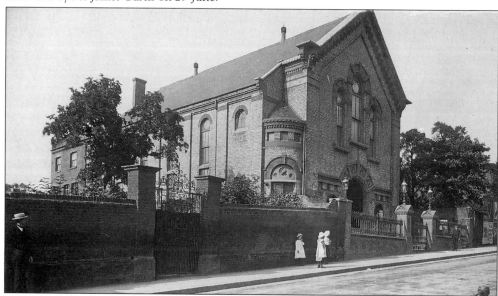

The Baptist chapel, East Hill, c. 1908. The church was founded in February 1869 by the Revd C.H. Spurgeon, pastor of the Baptist church. The originality of his sermons held congregations spellbound wherever he preached, and church attendances increased. The foundation stone at East Hill was laid by the local pastor, Revd. J.W. Genders, and the Revd C.H. Spurgeon, on 6 October 1862. This large and imposing structure is to be demolished in December 1994 due to settlement and problems with the foundations. A new church is to be built with attached housing.

Two
Wandsworth
High Street

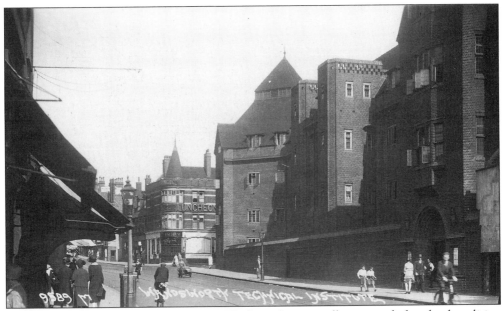

Wandsworth Technical College, c. 1928. Work on the new college started after the demolition of small shops and businesses in 1922/3. The President of the Board of Education, Lord Eustace Percy, opened the complex in November 1926. The cost of the building work was £70,000. Further demolition of shops led to a 109-foot extension along the High Street, which was opened on 3 December 1936 by Mr Ewart G. Gulpin, JP, Vice Chairman of the LCC. The original intention was that the Duke of York would carry out the ceremony, but the abdication crisis led to him being declared King George VI by 10 December.

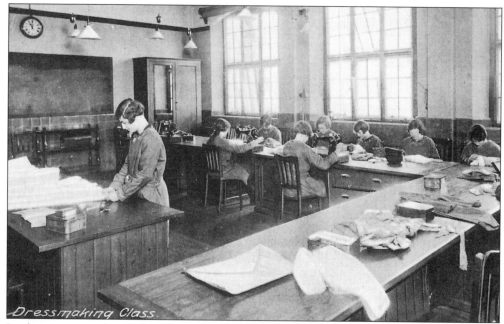

Dressmaking Class.

In these scenes, taken before the enlargement of the college, girls can be seen cooking and dressmaking in rooms used for the home management course. Courses were available in pure science, building, commerce, languages, and for those preparing for higher grades in the Civil Service. The college is now part of the South Thames College with other schools on West Hill and Putney Hill.

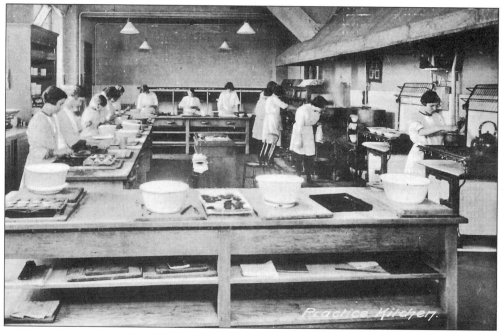

Practice Kitchen.

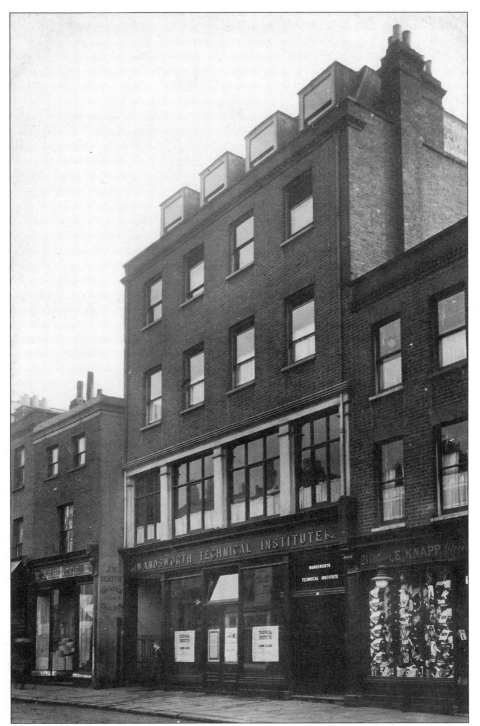

Wandsworth Technical Institute, 19 High Street, c. 1910. A series of lectures run by the LCC Technical Education Board given by Professor V. Lewis in 1894 led to the opening of the Wandsworth Institute in 1895 using St Georges Hall, a former skating rink. The building was demolished in 1922/3.

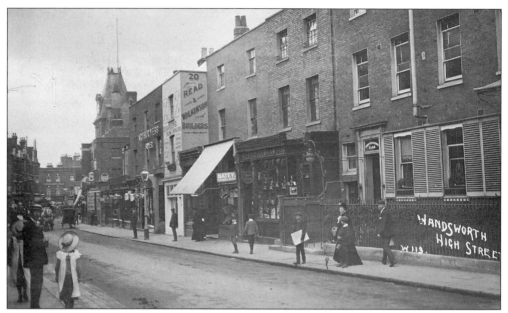

Site of the present Town Hall, *c.* 1908. This range of eighteenth-century properties was progressively demolished throughout the 1930s; the Council was clearing the area for new municipal buildings which were opened in 1937. In this view are the Constitutional Club; Collishaw, pharmaceutical chemist; Read and Wilkinson, butchers; and Arthur Webb, saddler.

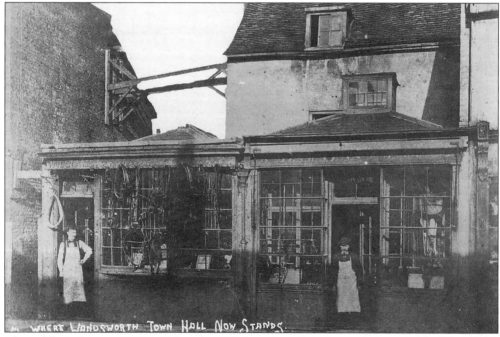

The saddler's shop at 48 High Street, *c.* 1880, later demolished to make way for the Town Hall (1882). William Evan Williams is listed in a directory of 1867 as having been established for a hundred years. An invention of his was a new type of horse collar that relieved horses of any chafing or pain. By 1866 he had sold 400 of these collars within eleven months and had ensured that the Lord Mayor's coach horses were soon to wear them.

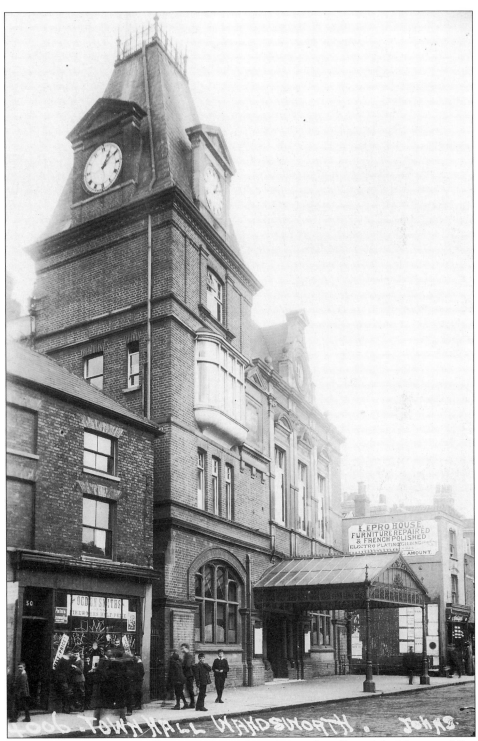

Wandsworth's early Town Hall, *c.* 1912, erected in 1882 as the office of the Vestry and Burial Board for Wandsworth and taken over by the Borough Council in 1900. Mr Capping's shop next door, with the young boys outside, is selling fireworks at half price.

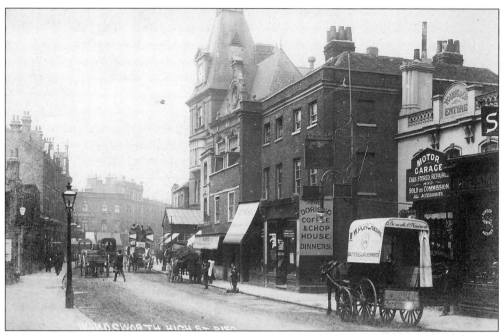

High Street, *c.* 1907. The Antelope Inn, a Young & Co. public house, occupied the white-painted premises; to the right is the small motor garage of G.L.M. Dorwald & Co. which had some connection with the Putney Motor Co. near East Putney Station. The garage here was used in 1922 to build the Chelsea electric car, a short-lived marque.

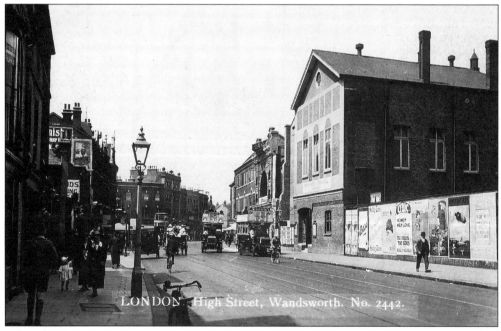

After demolition and road widening the Wandsworth Palace cinema and the Gas Board showrooms were opened. The larger building is the temporary Town Hall pictured in about 1925. This was enlarged and opened in 1927 as the Civic Suite, which is still in use.

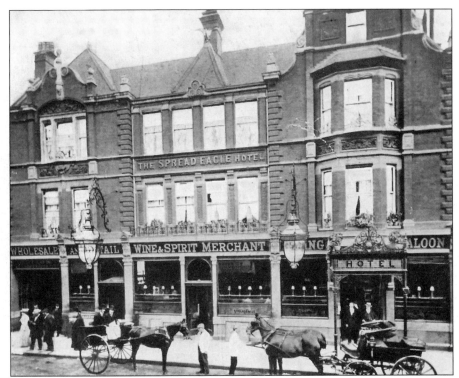

The Spread Eagle public house, seen here in 1908. Once known as the Black Spread Eagle, the pub's earliest records date from the 1780s but it probably goes back at least a century earlier. Founded within its walls were the Surrey Iron Railway in 1800 and the Wandsworth Gas Co. in 1834. The acid-etched windows inside are immaculate and date from Victorian times.

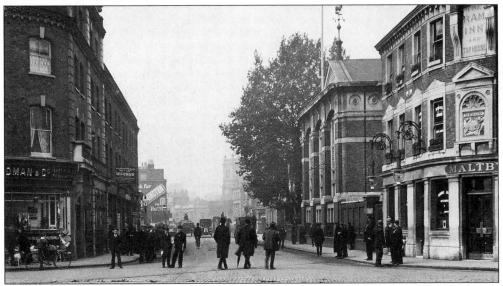

High Street at the junction of York Road and Garratt Lane *c.* 1912 with Young & Co.'s brewery on the right. Bank Buildings, Stimpson Buildings, and a range of small shops with a pedestrian walk parallel to the Wandle were demolished in 1967–8 for the large-scale development of the Arndale shopping and housing scheme.

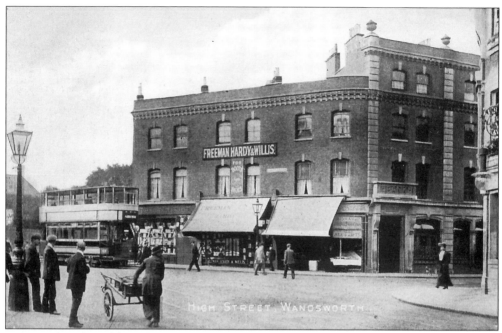

A view of Bank Buildings from York Road, *c.* 1907. Freeman Hardy & Willis, the shoe shop, was on this corner for some years; they also had a branch in the High Street.

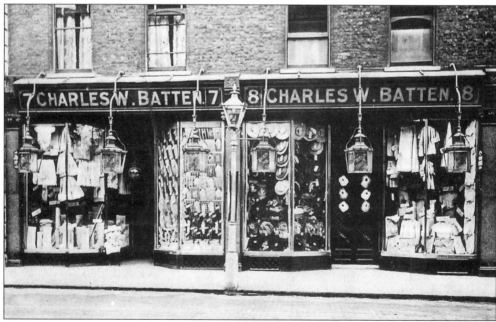

Charles Batten, 7–8 Bank Buildings, *c.* 1905. Charles Batten's was a small haberdasher and general clothing store that operated from the High Street frontage of Stimpsons Buildings. The firm had disappeared by 1908, no doubt due to stiff competition from Hardings, the large department store further along the High Street.

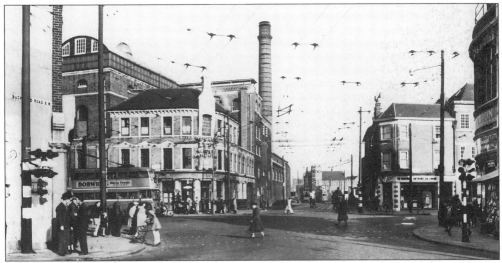

Young & Co's brewery, *c.* 1949. The brewery was first mentioned in the parish records when a Mr Langridge of 'The Rame' died on 13 April 1606, although a ram field in the vicinity is mentioned in medieval records. The Young family bought the brewery in 1831 and have expanded the works over the years. A steam engine built for the brewery in 1835 by a Wandsworth company, Wentworths, is still in working order. The brewery drays are still a common site within a short distance of the works. In the centre of the picture is the Salvation Army Citadel which has eight foundation stones, all laid on 20 April 1907.

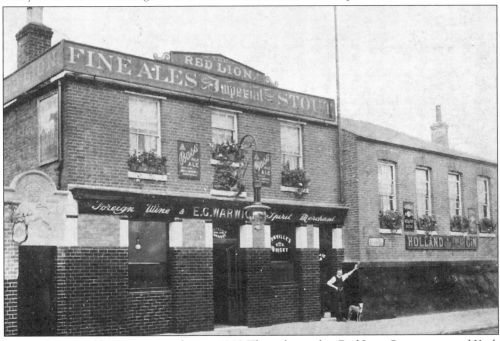

The Red Lion Public House, seen here *c.* 1908. The pub stood in Red Lion Street, renamed York Road and only recently renamed Ram Street. Probably of eighteenth-century origin, the pub backed onto the cut, a short canal from the Thames that ended at the rear of the Brewery dug as a dock for the Surrey Iron Railway in 1802. The Red Lion has gone, but some of the brown glazed tiles seen in the picture remain as part of the Brewery wall.

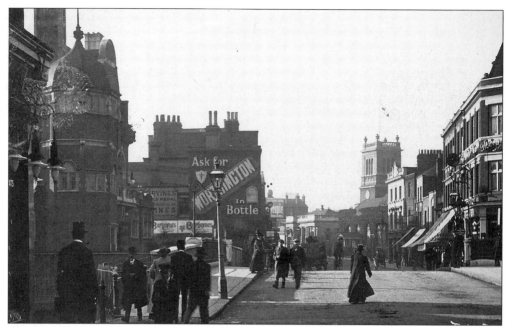

The High Street, *c.* 1912. The barely perceptible rise of the Wandle Bridge can be seen, with the Wandsworth Baths on the left. The Old Bull public house on the right, first mentioned in 1617, was destroyed on 14 October 1940. On the corner of the Plain is the Victorian Kings Arms public house, another early pub mentioned in 1703. The town's maypole stood in the High Street near the Plain and was removed in 1567 at a cost of 6d.

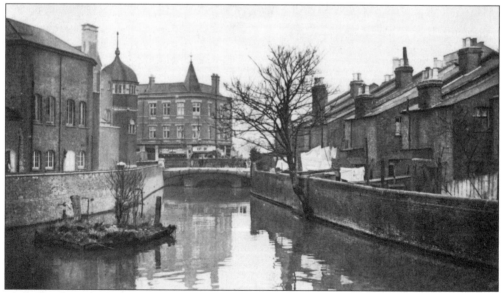

The Wandle seen from the original Buckhold Road Bridge looking towards the High Street. The first bridge in the High Street across the Wandle is mentioned in 1602, when Elizabeth I ordered that a bridge of stone be built. It survived until 1757. Rising near Croydon, the power of the river was harnessed by the erection of mills on its banks. Seven mills were mentioned as of the Manor of Battersea in the *Domesday Survey* of 1086, many of which were probably on the Wandle.

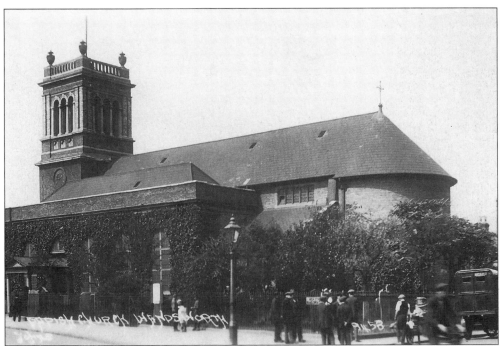

The upper picture shows the parish church of All Saints just after the First World War. The church was first mentioned in a Papal appointment of 1234. The fourteenth- or fifteenth-century tower of white stone (similar to the one belonging to St Mary's in Putney) was encased in brick in 1630. The north aisle was added in 1724, the nave in 1780, and the chancel in 1891. The tower was damaged when the bank next door took a direct hit during the Second World War, seen below with a temporary capping before reinstatement in 1955. The parish records, dating back to the sixteenth century, were kept in the bank for safekeeping during wartime, and much to local historians' regret the rate books were destroyed. Church Row in The Plain dates from 1723.

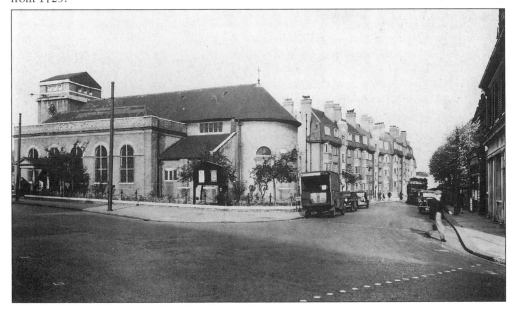

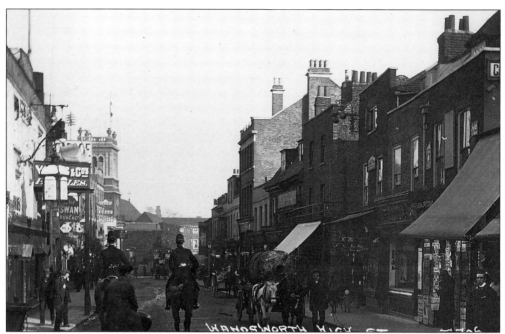

The High Street, *c.* 1912, facing east from the corner of Putney Bridge Road. Eighteenth-century shopfronts on the south side were soon to be swept away when the road was widened after the First World War. The Old Swan public house on the left, also dating from the eighteenth century, was demolished in 1924 for the erection of Alan Taylor's large Ford garage and works.

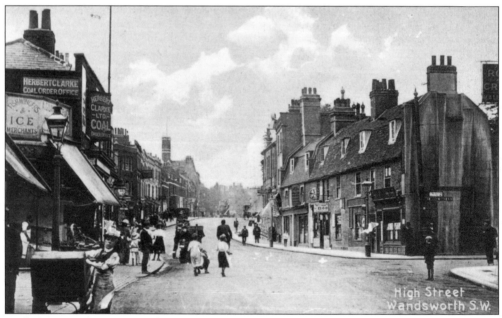

High Street with Putney Bridge Road on the right, *c.* 1908. Two of the small cottages on the right were demolished in the 1960s to facilitate the widening of the road junction, but the remaining four are probably the oldest secular buildings left in Wandsworth.

Three

West Hill

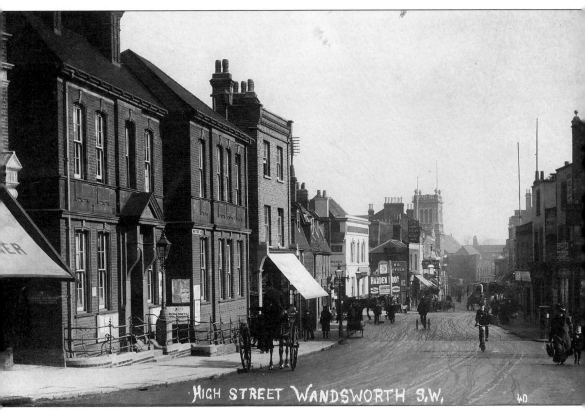

HIGH STREET WANDSWORTH S.W.

The Police Station, seen here in 1910, was built in 1883 to replace the old building which stood in Putney Bridge Road until Armoury Way was opened in the 1930s; further down is the office of the *Wandsworth Borough News* founded in 1883 and now the only local newspaper in Wandsworth. The white building is the original Rose and Crown public house, rebuilt in the 1930s, which has been given several names through the 1980s and up to the present.

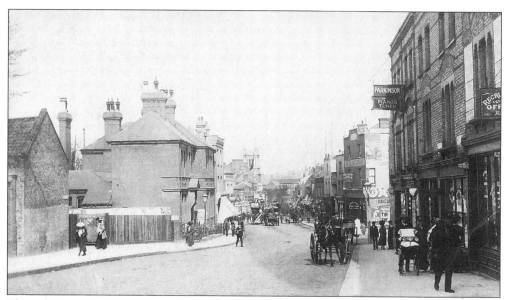

The police station in 1905, standing exposed by the recent demolition of buildings such as the Sword House, where in the past a sword could be borrowed for protection while crossing Wimbledon Common. The George and Dragon public house, sited a little further up the hill, also demolished, may have been the same pub as the The George mentioned in 1609. The archery butts set up 'west of the town' hereabouts in 1581 were managed by William Grosse, who was paid 3d for the training of soldiers in Wandsworth.

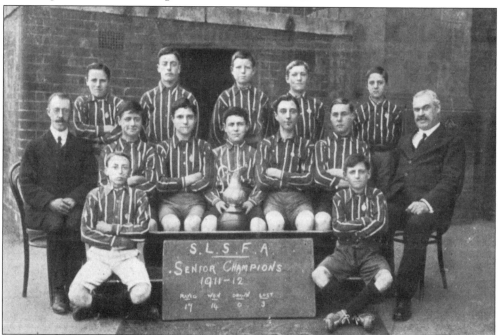

West Hill School senior football team were champions of South London Football Association for the year 1911/12; they are seen here in the school ground facing Broomhill Road. Their record was impressive—of the seventeen games they played, they won fourteen, drew none, and lost only three.

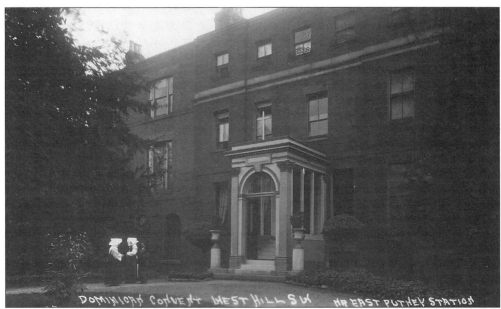

DOMINICAN CONVENT WEST HILL SW NR EAST PUTNEY STATION

The Convent of the Sacred Heart, 28 West Hill. In the seventeenth century, the site was part of a large estate. The main buildings stood on West Hill, most of the land being orchards and market gardens. In the second half of the eighteenth century the old buildings were demolished and a large house, called the Orchard, was built. The first known resident was John Wilmot, who sold on to Frederick Hahn in the late 1780s. He served in the Wandsworth Volunteers, set up in 1803 against a potential Napoleonic invasion. The family stayed there until some time between 1873 and 1877, when the estate was taken over by the Convent of the Sacred Heart, who retained the old building and added a new wing, chapel, and school in 1881, as a teacher training college which also had a well-endowed science laboratory. The site was purchased by the Council in 1974 for housing development and the old house and additions were demolished. The new housing estate is called The Orchard and the old lodge on West Hill remains.

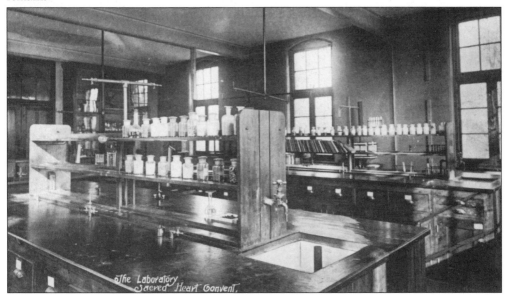

The Laboratory
Sacred Heart Convent.

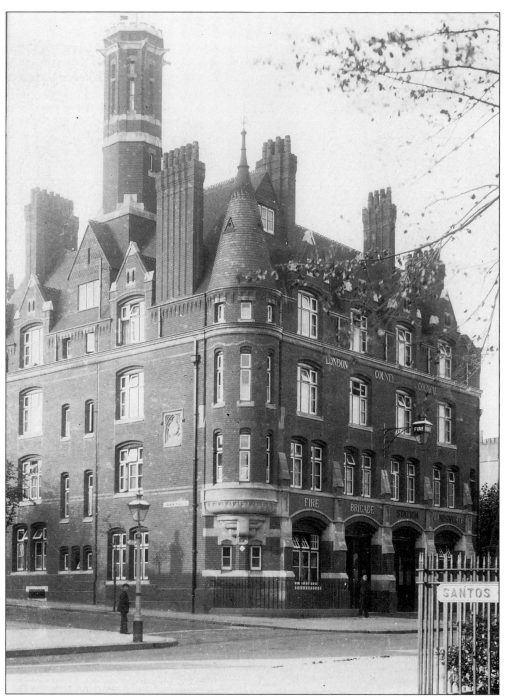

The fire station, West Hill, c. 1907. Built by the LCC during the 1890s, the station progressing from owning a horse-drawn engine with steam pumps to the most modern appliances of the 1930s. In November 1940, the station was bombed and in the resulting fire six firemen lost their lives. The building was partially rebuilt but was demolished after the war, and the present station dates from 1955. A small plaque in a garden of remembrance stands in front of the station, and each November the six men are commemorated.

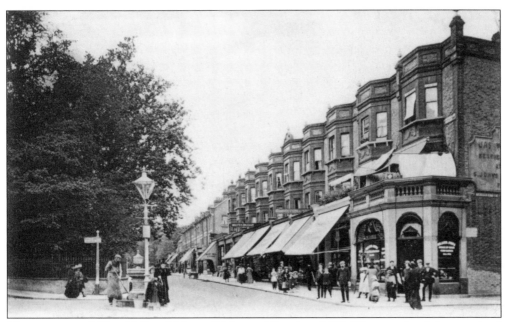

The junction of West Hill and Upper Richmond Road, *c.* 1903. The parade of shops erected during the 1880s supplied almost every requirement of the neighbouring streets. The small drinking fountain by the lamp was donated anonymously in 1897.

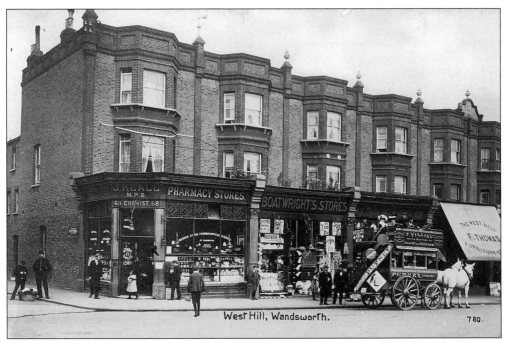

West Hill at the junction with Mexfield Road in 1908. Thomas Tilling of Peckham had a series of depots across London, and in this scene is one of his horse-drawn buses en route from Putney to Clapham. Mr Keall's pharmacy has a colourful display of oil and drug jars in the window and Boatwrights are selling everything from tea and Bovril to brooms and crockery.

The junction of West Hill and Upper Richmond Road as seen from the fire station tower in 1914. At the top left, the upper part of the secondary school for girls (Mayfield School) can be seen. Among the trees is the roof of Suffolk Hall, originally built as a public house but a licence was never issued: the building was used as showrooms.

The church of St Thomas of Canterbury from the fire station tower, 1914. Designed by Edward Goldie, the foundation stone was laid on Saturday 23 September 1893 by Bishop Butt, and it opened on 28 July 1895. The tower was completed in 1926 and the large bell, installed in 1927, was dedicated to the Ven. John Griffith, the last Catholic priest of All Saints church, who was hung, drawn, and quartered on 8 July 1539 due to the intrigues of Thomas Cromwell, who was born of a Putney blacksmith.

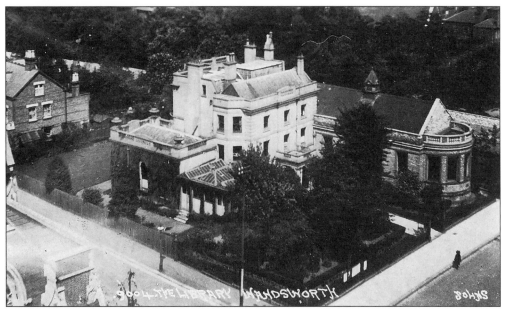

West Hill Library, *c.* 1914, South London's first library. The reading rooms were first opened in March 1885. The Longstaff reading room was the gift of George Dixon Longstaff, first Chairman of the Libraries Committee, to commemorate the Queen's jubilee year and his own fifty years of residence in Wandsworth. Formerly called the Putney Lodge, the library was rebuilt and reopened on 15 October 1937 retaining the Longstaff reading room. Putney Lodge, the larger building in this view, was occupied for some years by the horticulturist Sigismund Rucker.

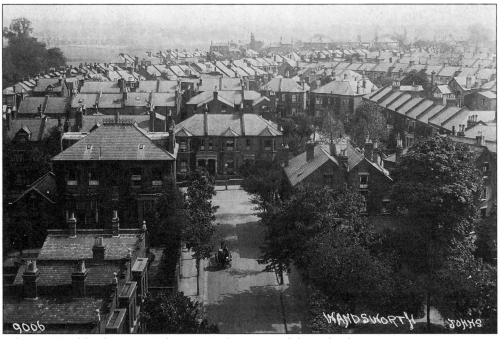

Lebanon Road leading into Lebanon Gardens, viewed from the fire station tower in 1914. A fine cedar of Lebanon tree existed at Lebanon house, which stood here.

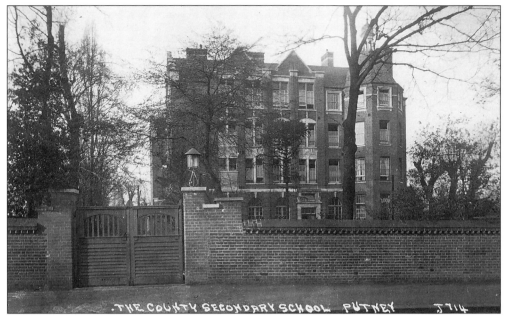

Mayfield School, West Hill, c, 1914. Built in 1909 as the County Secondary School for Girls, it was enlarged in the 1950s and had over 1,000 pupils. The modern part is now the City Technology College, opened on 4 September 1991. The old school building, badly damaged by bombing in February 1944 and again later in that year by a V1 flying bomb, is now part of the South Thames College.

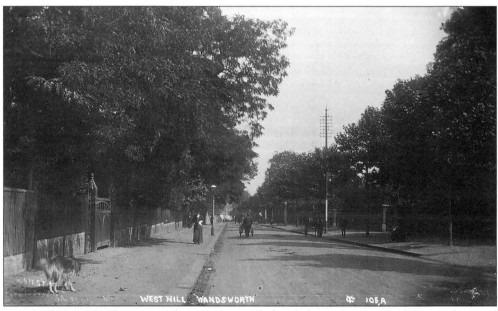

West Hill, c. 1907. The route to Kingston was filled with large mansions with big gardens and carriage drive entrances. Among those living here were Sir Henry Kimber (1834–1923), Conservative MP for Wandsworth from 1885 to 1913 at Landsdown Lodge, and at Ravenswood, John William Lorden, MP and JP for Wandsworth in 1922.

Four
Buildings and People

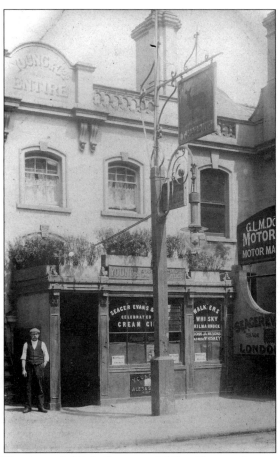

The Antelope Inn, Wandsworth High Street, c. 1907, a Youngs Brewery public house which was demolished in preparation for the building of the new town hall (see page 20).

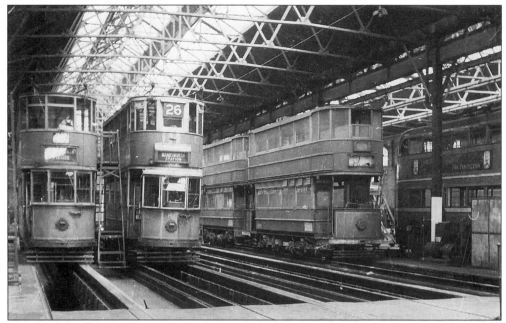

Jews Row tram depot in 1950. The South London Tramway Co. built the depot in 1882 and the LCC virtually rebuilt it to house the new electric cars in 1906. Taking only nine months to erect, and costing £29,000, the LCC used their own labour. Space was created for 106 double-deck trams, which were slowly replaced by trolley buses from 1937. Both tram and trolley bus services vacated the building on 30 September 1950, when the building was converted for the use of buses.

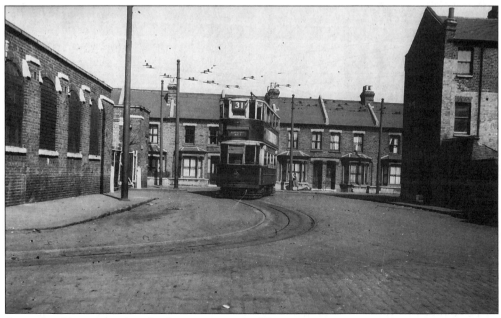

A number 31 tram leaving the depot en route to Islington.

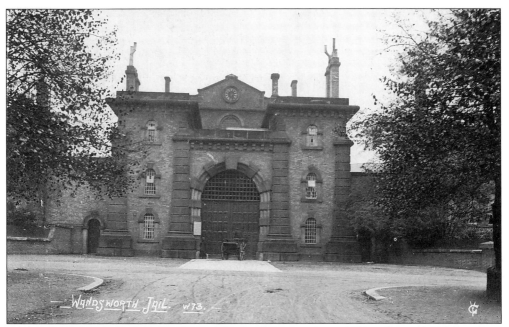

Wandsworth Prison, built as the Surrey House of Correction in 1851 to house 1,000 prisoners, both male and female. The last gallows in a British gaol has only recently been removed; many wartime spies were hanged at Wandsworth. Infamous guests have included Rudolph Hess after he flew to Britain during the Second World War, and Ronald Biggs of the 1963 Train Robbery who escaped and is, in 1994, still at large in Brazil—his cell awaits him.

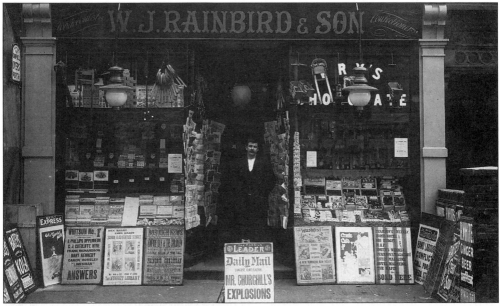

Mr Walter J. Rainbird stands in the entrance to his newsagent's shop at 270 Earlsfield Road in May 1907. Aniseed balls would set you back a penny for sixteen; Players cigarettes were ten for $2\frac{1}{2}$d and a copy of the *Wandsworth Borough News* reporting the laying of the foundation stone for St Andrews Parish Hall by Princess Alice could be yours for a 240th of a pound!—one penny.

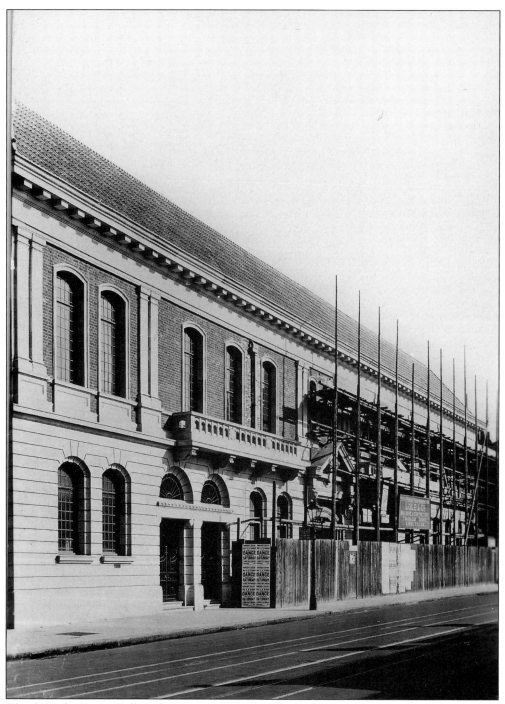

Wandsworth Town Hall under construction in 1926/7. This structure still survives as the entrance to the Civic Suite, where several large halls are available for functions.

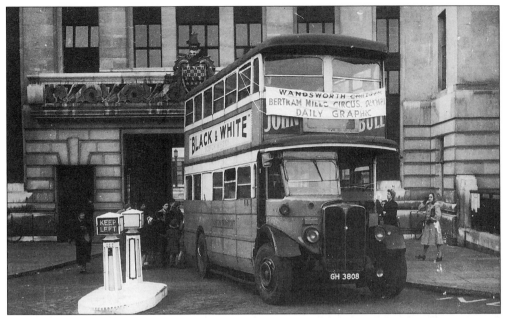

A children's special treat was to be taken to the circus from the Town Hall, courtesy of various charitable organisations. Here an ex-London General Omnibus Co. AEC Regent is leaving the Fairfield Street entrance in December 1948, carrying the children to see Bertram Mills' Circus at Olympia, West Kensington.

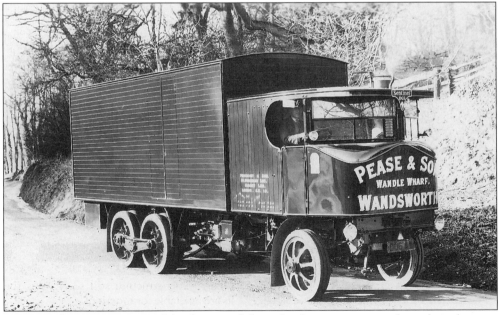

A Sentinal steam wagon used by Pease and Sons, haulage contractors, from their depot at Wandle Wharf, and also from Fairfield Street during the 1920s. The photograph was taken for Sentinal with each new vehicle produced.

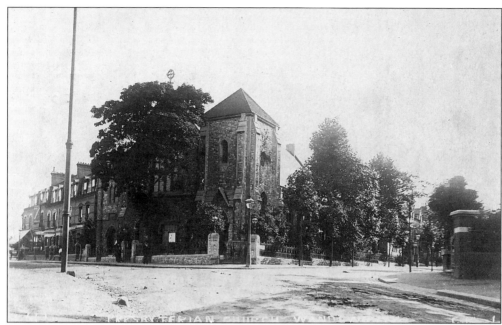

The Presbyterian church on the corner of Merton Road and Lebanon Gardens, *c.* 1907. In 1922, the Revd Alfred Josiah Haggis lived at 22 Amerland Road, nearby. The church was destroyed during the Second World War, but when a small development of flats was erected on the site the church wall was retained and it survives today. A short section of Merton Road from the High Street to Southfields Road was called Back Hill in 1841 and the pound for stray animals that stood near this spot was removed in 1861.

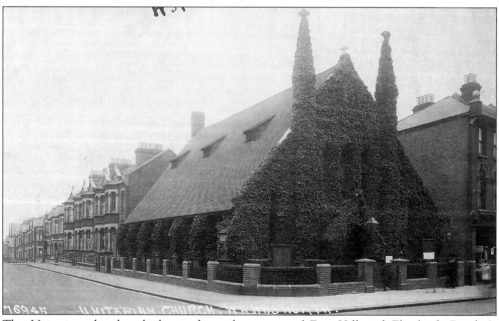

The Unitarian church, which stood on the corner of East Hill and Elmsleigh Road. It disappeared during the construction of the underpass for the Wandsworth Bridge approach scheme, opened in 1970.

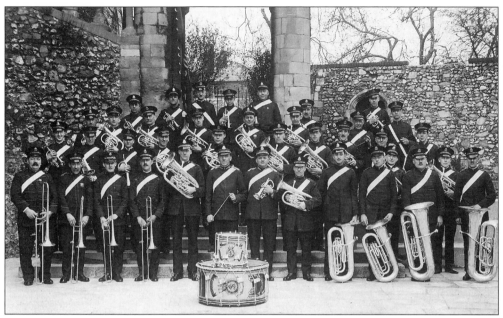

Wandsworth Salvation Army Band. Bandmaster Mr Knott, with baton, leads the band of No. 126 Corps Wandsworth at Canterbury in 1928. The local 'Citadel' being in York Road, now Ram Street, was built in 1907. Prior to this, they used the old Baptist church in North Street, since renamed Fairfield Street.

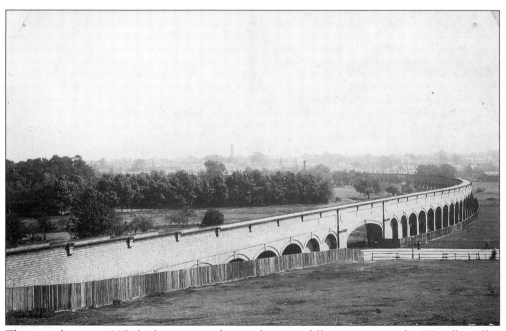

The aquaduct, c. 1907, built to carry the southern outfall sewer across the Wandle valley towards the Kent coast. The view is from Merton Road with the tower of St Ann's church on the skyline. The larger arch is where Buckhold Road passed beneath. King George's Park was not built until 1923. The aquaduct was demolished in 1968.

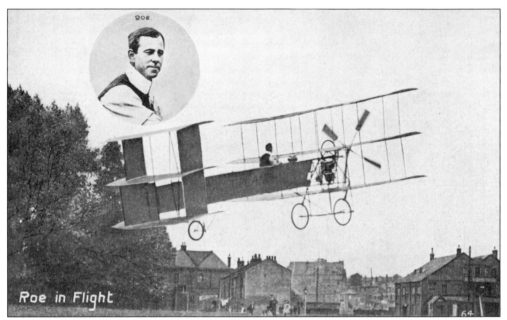

Roe in Flight

Alliot Verdon Roe became the first Briton to fly an all-British aeroplane on 13 July 1909 at Hackney Marshes. His success led to the formation of Avro Aircraft, who built such successful planes as the Avro 504 and the Lancaster, and he was involved in the vast postwar Saunders Roe Princess. His first three aircraft, including the triplane in this picture, were built in the stables of his brother's house at 47 West Hill, two doors up from the fire station, now demolished and part of the Longstaff Housing Estate.

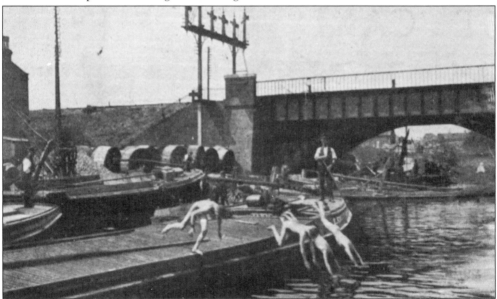

McMurray's Canal or The Cut in 1904. The Waterloo to Windsor railway line crosses the canal that ran from the Thames almost to the rear of Youngs brewery. Built in 1802 as a transfer dock for the horse-drawn Surrey Iron Railway that ran from the dock at Wandsworth along Garratt Lane, through Merton and Mitcham to Croydon. The canal survived into the 1920s, when it was filled in.

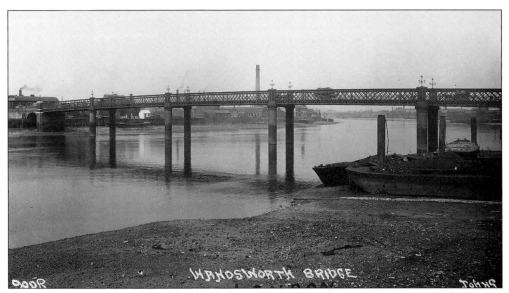

Wandsworth Bridge, *c.* 1914 (above) designed by Mr J. Tolmé; the lattice girder bridge on wrought iron cylinders had three central spans of 133 feet. It was built by the proprietors of the Wandsworth Bridge Co. and opened in 1873 by Colonel Hogg, MP. The bridge was freed of tolls by a ceremony performed by the Prince and Princess of Wales on 26 June 1880. As seen below, the bridge was small and unable to cope with modern traffic. It was replaced in 1938 with the present bridge which was designed by Mr E.P. Wheeler.

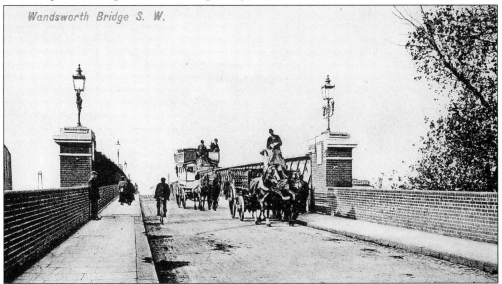

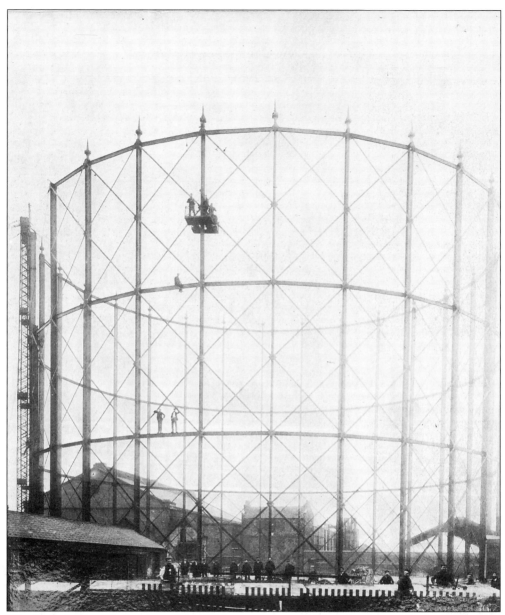

Wandsworth Gas Works, formed in 1834 at a meeting held at the Spread Eagle. Production began in Slough Lane, which was an earlier name for North Street, now called Fairfield Street. Amalgamations between various concerns resulted in the formation of the Wandsworth and District Gas Co. On expansion, the work's coal was brought direct to a Thames-side wharf in 1906 and from 1909 they had their own fleet of colliers. The twelve-acre area covered almost the entire river front from the bus depot by Jews Row to Feathers Wharf near the Wandle. The new gas holder, erected about 1890, was 150 feet in diameter and was retrieved into a water-filled tank thirty-five feet deep. The site closed in 1971.

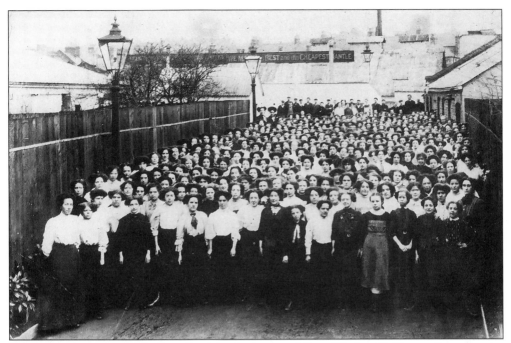

Women workers at the Voelker Gas Mantle factory, Albert Works, 57 Garratt Lane, on the corner of Malvin Road, in January 1910. Gas mantles were in constant demand due to the fragility and short life span of the spiders web filament. The young ladies of one department appeared in the *Daily Graphic* dated 25 January 1912 for going on strike due to objection to the employment of a particular forewoman.

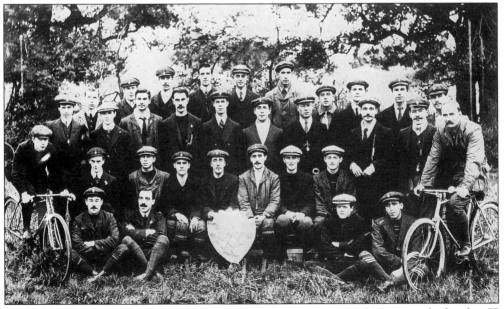

Earlsfield Wheelers Cycle Club in 1907. The Hon. Secretary was Mr L. Lovett, who lived at 57 Swaffield Road, the lodge of the LCC school, where the headquarters of the club was housed. Many of these small, social cycle clubs that gave pleasure and exercise to their members were formed at the turn of the century.

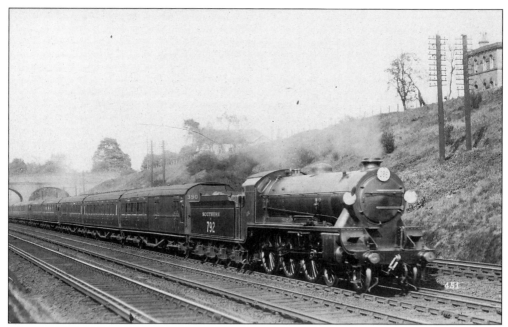

The Bournemouth Express passing through Wandsworth Common cutting during the 1930s. Heathfield Road bridge is to the left, and a small portion of the prison can be seen on the right. For railway buffs the engine is Sir Hervis de Revel type 4-6-0, No. 792, operated by Southern Railways, and is of King Arthur class.

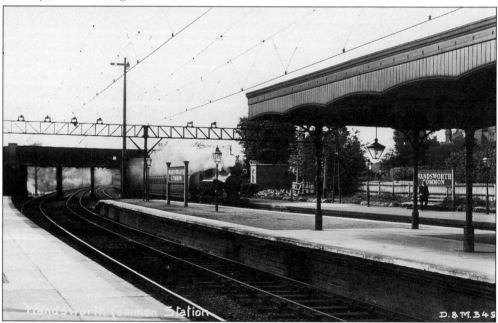

A 'D' class locomotive on the suburban services of the London, Brighton and South Coast Railway Co. pulling into Wandsworth Common station about 1912. In 1911, early electrification was via overhead gantries; the trains used the pantograph collection system and converted to third rail system in 1929. Bellevue Road bridge is to the rear and the entrance to the coal depot is on the right.

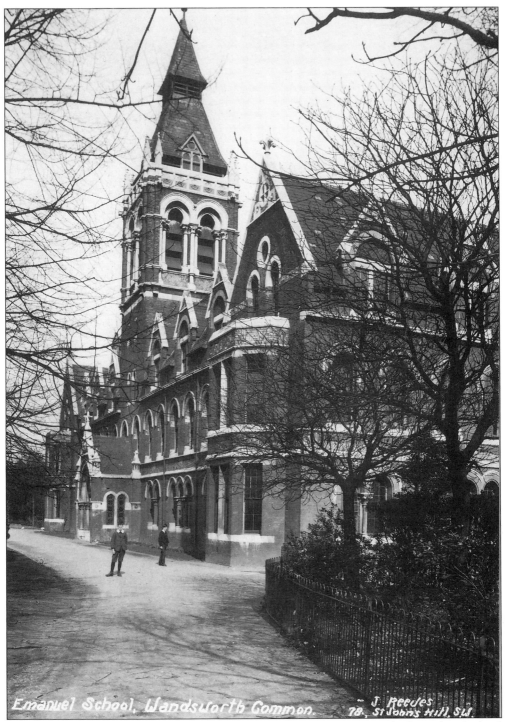

Emanuel School, Wandsworth Common. — J. Reeves 78, St Johns Hill, S.W.

Emanuel School on Wandsworth Common, seen here in about 1907, was built as a boys' school for the Royal Patriotic Asylum in 1869. Without enough orphans to claim entrance, the school was sold off for £30,000 in 1881. Emanuel School has occupied the building for over a hundred years (see page 54).

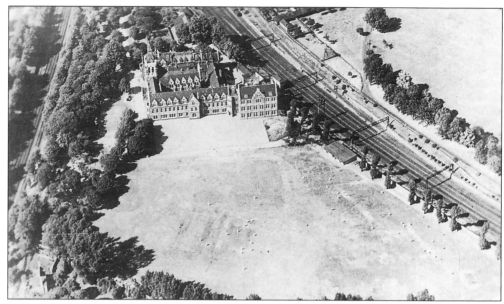

Emanuel School from the air, *c.* 1925. Boys are out on the school playing field dressed in their whites, probably playing cricket.

Wandsworth Park, Putney Bridge Road, with its well-tended flower beds, in 1911. At a meeting at Wandsworth Town Hall in 1896 a decision was made to acquire the former market gardens and rubbish heaps for public pleasure as a park. The land, costing £30,000, was bought by the LCC together with donations from local people. The park was formally opened on Saturday 23 February, 1903.

Five
Wandsworth Common

As part of the manorial wastelands of Wandsworth and Battersea, the common was facing gradual encroachment by the Lord of the Manor, Earl Spencer. This alarmed local and eminent people and the foundation of this public open space in 1871 saved 175 acres. The ponds were formed by gravel diggers taking material for repairing local roads. This scene, in 1910, is at 3 island pond off Bolingbroke Grove.

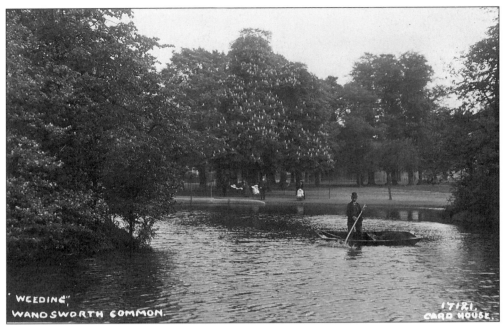

"WEEDING",
WANDSWORTH COMMON.

17181.
CARD HOUSE.

A bowler-hatted gentleman weeding 3 island pond in 1910 from the safety of a small wood punt. This pond still suffers from weed growth and has to be managed regularly because of the lack of a natural running supply of water.

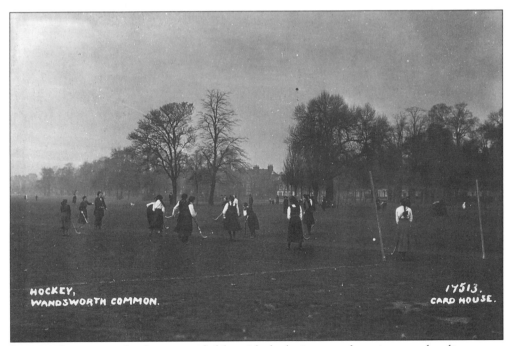

HOCKEY,
WANDSWORTH COMMON.

17513.
CARD HOUSE.

Sport on the common has been provided for with the laying-out of tennis courts, bowling green, cricket and football pitches. Here we see young schoolgirls engrossed in a game of hockey shortly after the First World War.

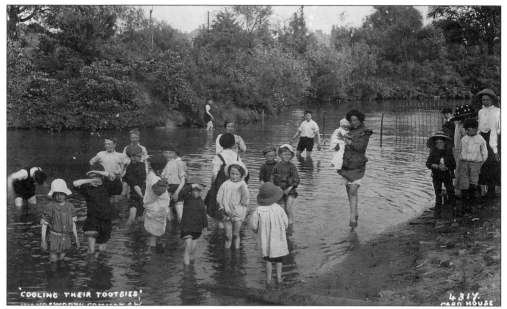

The pond near the railway cutting north of Bellevue Road in 1908, with a group of children taking a dip during their summer holidays. Many families did not take holidays before the First World War, and local commons and parks would be inundated daily with hoards of children.

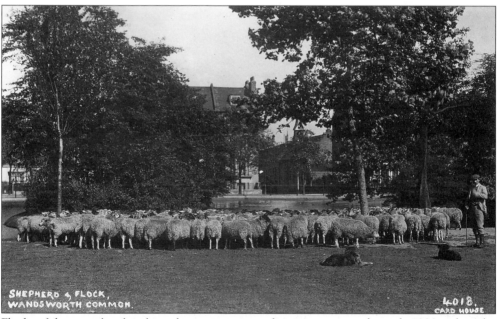

Flocks of sheep on local parks and commons were often seen prior to the early 1920s, when the increase in traffic led to the death of sheep and shepherds' dogs. With 4–500 animals in each flock, the mainly Scottish shepherds would move about Tooting, Clapham, and Wandsworth Commons, then take the sheep to Finchley or Hyde Park for shearing before the late autumn. The sheep were afterwards taken to the London markets. The scene is, again, of 3 island pond, about 1910.

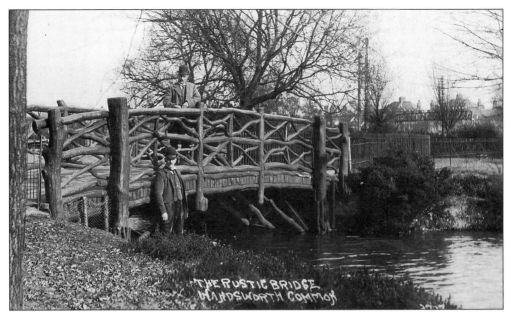

The wooden rustic bridge over the pond was replaced by a stone bridge during the 1920s. The upper scene, dating from about 1912, has bowler-hatted gentlemen probably inspecting the bridge for the Council. The lower, snow, scene is dated 30 December 1908.

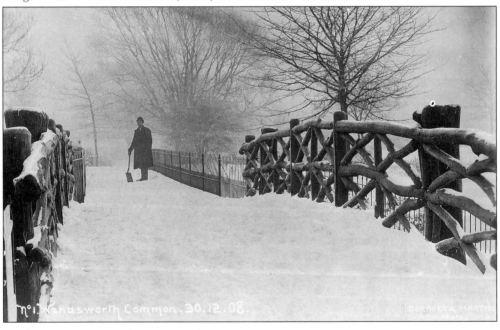

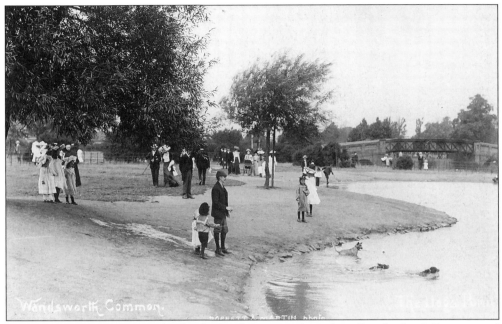

Sunday on the common was the day for families to parade in their 'Sunday best'. Panamas and boaters together with frock coats were not unusual wear and not a single person in this view, from 1910, is without a hat of some size or design.

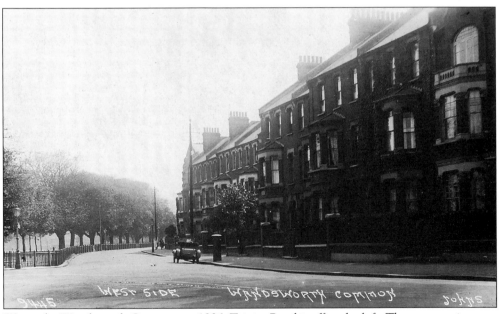

West side, Wandsworth Common, c. 1926. Trinity Road is off to the left. These properties were among the first to be erected by the common, and medical doctors and ex-admirals were among the residents.

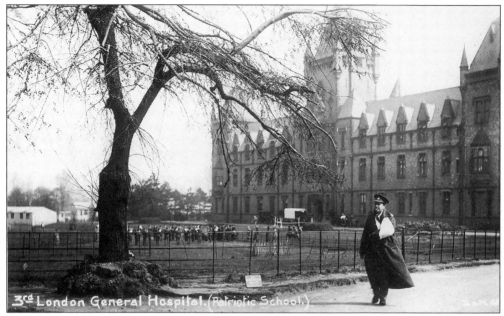

3rd London General Hospital. (Patriotic School.)

In aid of the many orphans of the Crimean War, a patriotic fund was set up in 1854 and within a short time the embarrassing sum of £1.5 million was raised. Many survivors and widows were awarded pensions and offered relief by the fund, and the residue was used to build the Asylum. The foundation stone was laid by Queen Victoria on 11 July 1857, and the building was erected at a cost of £31,337. Building was completed in two years. The architect was Major Rohde Hawkins. Both of these scenes were taken during the First World War.

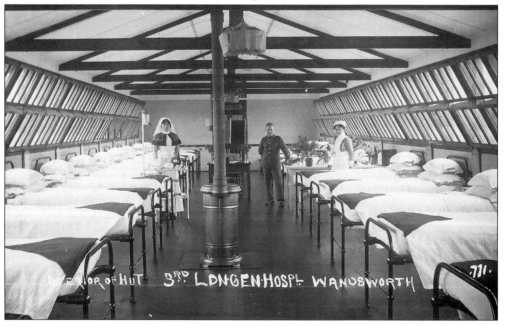

INTERIOR OF HUT 3RD LONGEN HOSPL WANDSWORTH

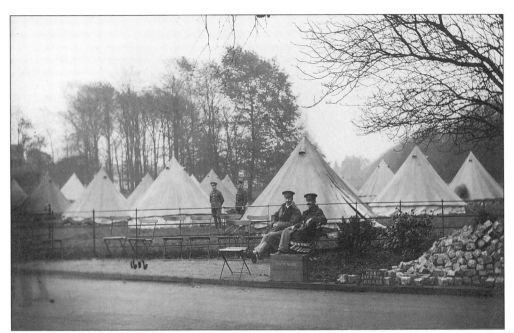

From August 1914 and during the First World War, the Asylum was used as the third London General Hospital. The grounds were filled out with tents and huts which held up to 1,800 patients. The railway cutting alongside was lowered to allow patients to be off-loaded direct from hospital trains. The premises were reoccupied by the orphanage until the Munich crisis of 1938, when they were relocated to Wales. They were eventually settled at Bedwell Park, Hertfordshire, and the orphanage was finally closed on 8 July 1972, solely due to the lack of orphans. During the Second World War the building was used as an internment camp for aliens and a clearing house and interrogation centre for refugees from Europe. The 1950s BBC TV series *Spycatcher* told a part of the story within these walls.

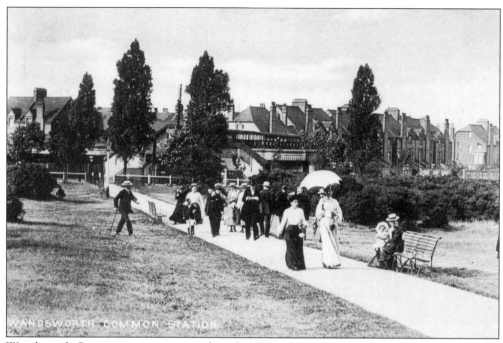

Wandsworth Common station as seen from St James's Drive in 1907.

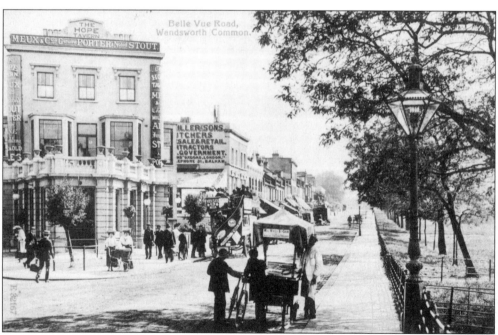

Bellevue Road, Wandsworth Common, c. 1904. The Hope Tavern is a mid-Victorian addition to Wandsworth's list of public houses. A Thomas Tilling horse-drawn bus en route to Tooting from Clapham Junction is collecting passengers, while an ice cream vendor is busy with two boys in the foreground. Railings for keeping sheep on the common were only removed at the beginning of the Second World War.

56

Six
Wandsworth Streets

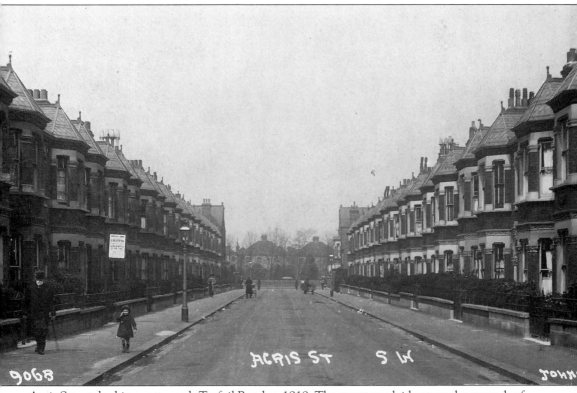

Acris Street, looking up towards Trefoil Road, *c.* 1919. The street was laid out on the grounds of Ivy House and East Hill Lodge, which both faced the common.

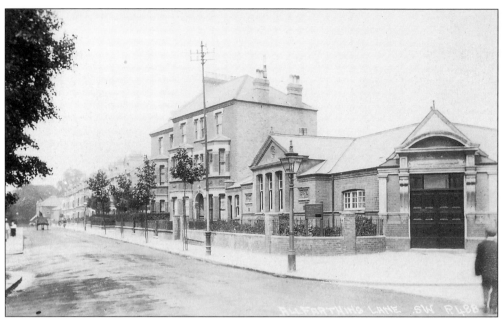

The Eastern Branch Library in Allfarthing Lane was built in 1898 with the help of a bequest given by Mr George Nind, and the site was given a peppercorn rent by Mr A.A. Corsellis. The Library was destroyed by bombing on 16 April 1941, and a temporary library was set up in a private house in nearby Rosehill Road in January 1942. A new library was opened to the public on 1 March 1961 with the official opening ceremony taking place on 27 April 1961, almost twenty years to the day after destruction.

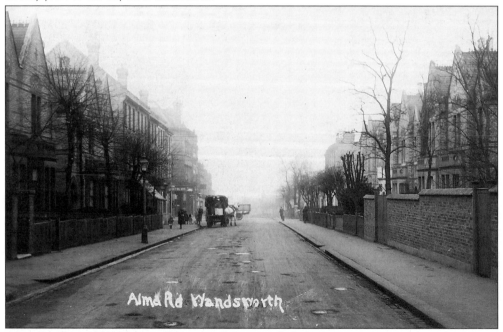

Alma Road, c. 1908. The small parade of shops included Mr James Summersby's shoe repair shop and the offices and works of the Brighton Sanitary Laundry. On the following corner of Fullerton Road stands the East Hill Hotel public house.

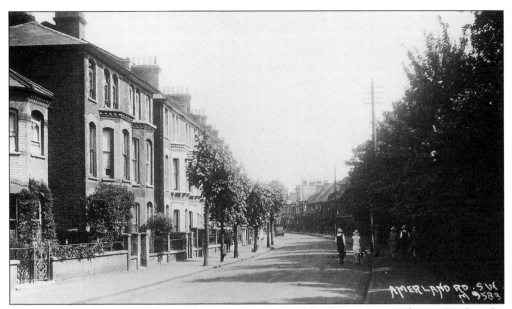

Amerland Road, *c.* 1926. The road name was approved by the LCC as early as 1869 but the houses in the road are the result of piecemeal development by small builders of two, four or six houses at any one time.

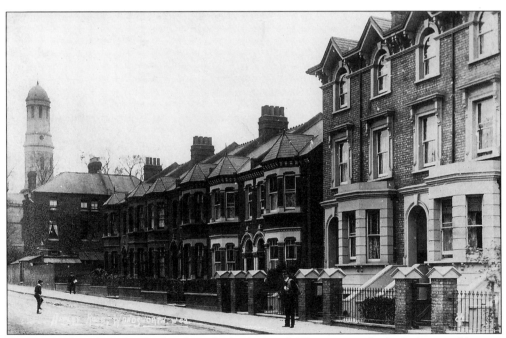

Aspley Road, with St Ann's church in the background. The postmen had a lucky round here as in 1905, when this scene was recorded, the sorting office was less than 200 yards away.

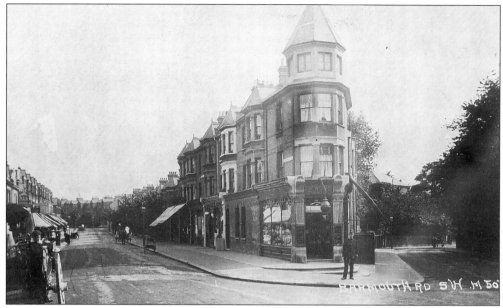

Barmouth Road, at the junction with Allfarthing Lane, *c.* 1908. Cecil Aubrey Manning, councillor for Springfield ward, lived at number 51, while Mr J. Wood ran the chemist's shop for some years supplying a wide range of drugs and surgical requisites. He was an agent for Kodak photographic materials and also supplied his own 'Wood's amoline cream, unequalled for softening and beautifying the skin'.

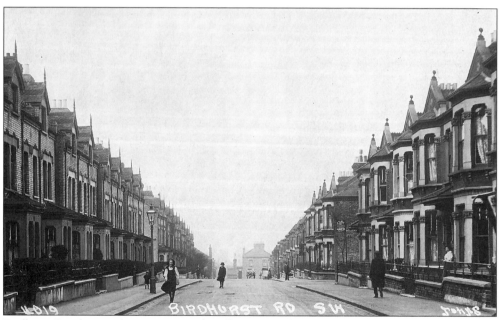

Birdhurst Road, near the junction with Fullerton Road, *c.* 1914. At number 13, in July 1958, died Mr Nathaniel Charles Berry who had worked at Price's Candle Works on the Battersea riverside for fifty-one years.

Broomhill Road and Buckhold Road on 28 July 1923, when King George V and Queen Mary visited Wandsworth to open Southfields Park, renamed King George's Park in their honour. Here we see the rows of seats put up for the occasion in front of the Welsbach incandescent gas mantle factory in Broomwood Road and the marquees erected for the event.

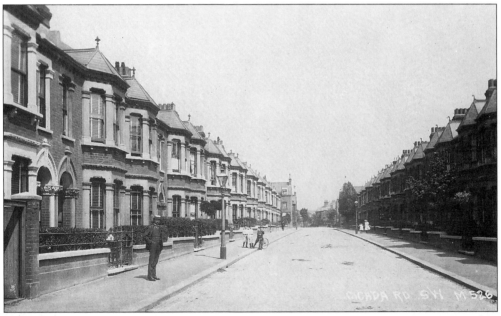

Cicada Road, *c.* 1906, facing the direction of Melody Road. The majority of houses here date from the 1890s. Wooden Venetian blinds were used to cover the windows to save interior furnishings and decoration from discolouration by sunlight. In 1935, the local office for the NSPCC was run by Mr Cecil Bailey from number 76.

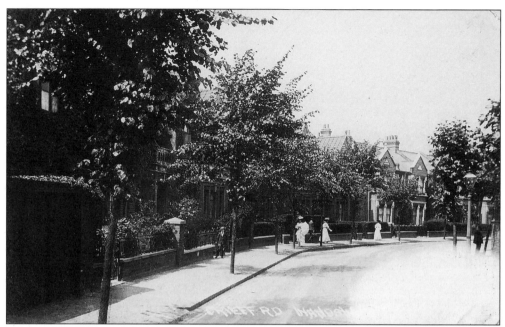

Crieff Road, *c.* 1906. In 1957 Mr Albert Ernest Sawyer of number 27 died; he had been a member of the Salvation Army since 1900. At number 28, in 1922, lived C.L. Taylor, vaccination officer for the Putney district of the Wandsworth Union of Guardians, the health board for the area.

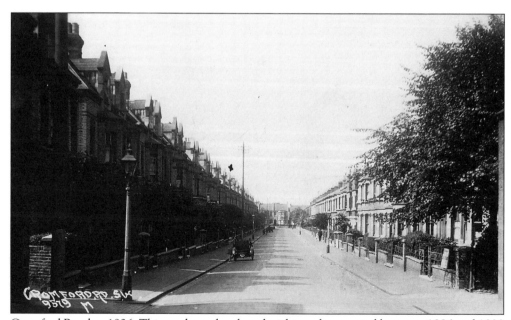

Cromford Road, *c.* 1926. This road was developed within a short period between 1886 and 1890 with the road name having been approved in 1883. On the night of 17 October 1940 the houses here suffered damage from a high explosive bomb; the same night as nearby Mexfield Road suffered.

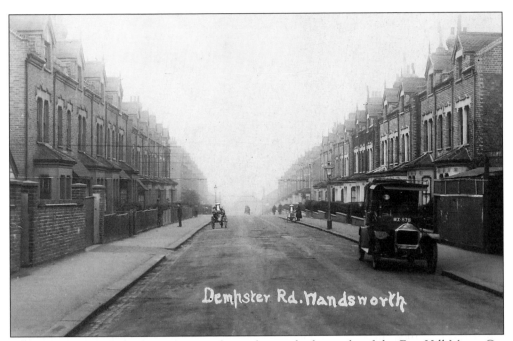

Dempster Road, *c.* 1908. A Unic taxicab stands outside the works of the East Hill Motor Co. The other vehicles are only hand-pushed three-wheel dairy carts that had to be pushed around these streets as often as three times a day.

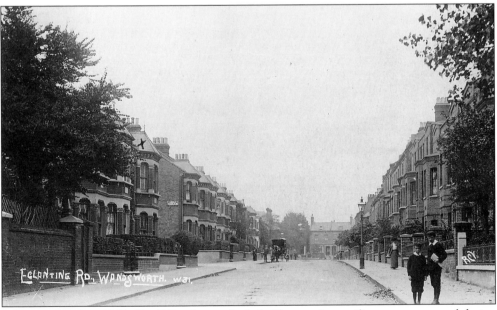

Eglantine Road, *c.* 1908. Knoll Road is to the left. The cast iron railings were removed during the Second World War for use in the manufacture of munitions. The contractors caused a great amount of damage in the early stages to walls, steps, and coping stones.

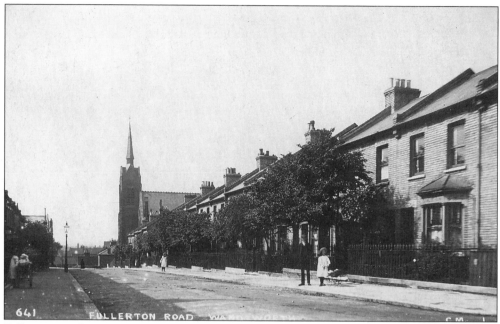

Fullerton Road in 1906. The imposing tower of St Faith's church, consecrated on 1 November 1883, had to be demolished in 1967 after a dangerous structure notice was issued due to unsafe brickwork. The boy and girl on the right are Harry and Myrtle York, whose father, Mr George York, worked as an insurance agent from their home at number 13.

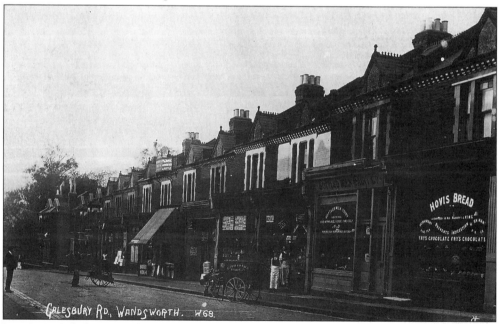

In 1906, Galesbury Road still had its full compliment of shops, bakers, a dairy, grocers, newsagents, a clothing store, and a wine and spirit store. This view shows the full length of Galesbury Road, only sixty or seventy yards. Nearly all of the shops have since been converted into private accommodation. Mr W.C. Reed, listed as a fruiterer at number 10 in 1922, rarely stocked any fruit and even had difficulty in purchasing vegetables for his shop.

The publican of the Old Turks Head public house in the rear garden of the pub which was at number 63 Garratt Lane, alongside the Voelker gas mantle factory and on the other side was the acquaduct as it crossed Garratt Lane. Demolished during the 1930s, the site is now used by an auctioneer's firm.

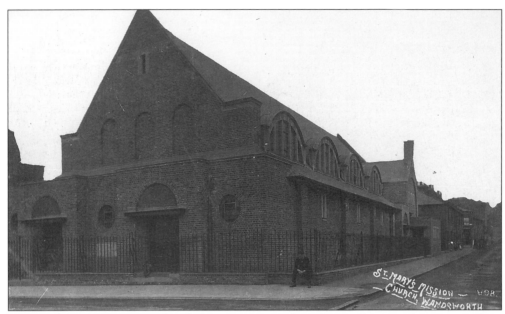

St Mary the Virgin, mission church for St Ann's parish in Garratt Lane on the corner of Iron Mill Place. The foundation stone was laid by Queen Victoria's daughter Princess Christian on 5 July 1904, two years earlier than the photograph. The architect was E.W. Mountford who also designed the public library, polytechnic, and Town Hall in Battersea. The Earlsfield Boxing Club, founded in 1945, use the rear of the church as their headquarters.

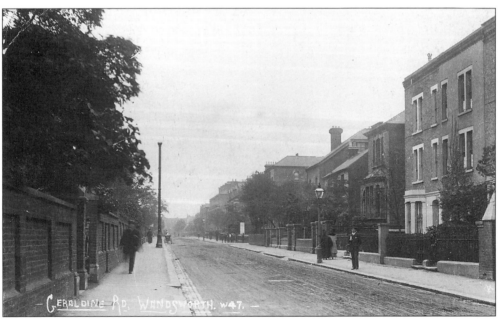

Geraldine Road, *c.* 1907. By 1920, Mr Arthur Roam Saunders, FRCO, was teaching music at his address, number 14, styling himself as a professor of music, but by 1935 it had been transformed into the Wandsworth School of Music.

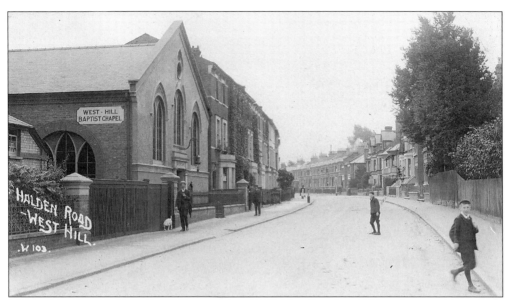

Haldon Road, *c.* 1907. H.G. Wells moved to 28 Haldon Road in 1891 and married his cousin Mary Wells at All Saints Church, Wandsworth High Street, on 31 October 1891. He moved to Sutton in 1893. In his *War of the Worlds* he mentions that ' … at Putney, the bridge was lost in a tangle of weed … a Martian out by Wandsworth, picking houses to pieces …'. The Baptist chapel was originally used as a roller skating rink. Living at number 62 in 1922 was a professor of music, Miss E. Ding.

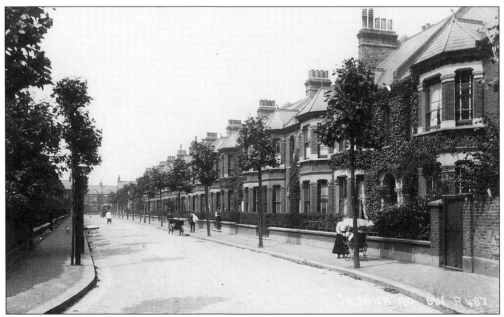

Jessica Road, *c.* 1906. Although the road name was approved in 1891, and the road laid out soon afterwards, house building only commenced in 1894 with the erection of twenty-four private houses on the north side with the south side waiting until the following year.

Knoll Road, *c.* 1906. It was built on part of the Lawn estate commencing with sixteen properties in 1887 followed by eighteen more in 1888, the last two being laid down as late as 1894.

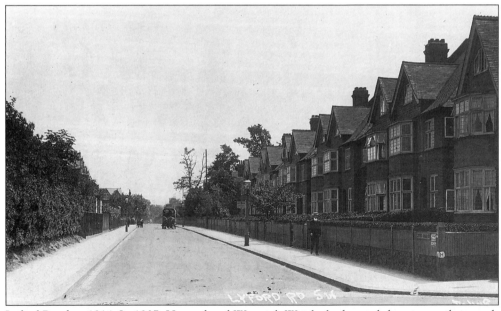

Lyford Road, *c.* 1914. In 1907, Howard and Warwick Wright had a workshop in a railway arch at Queen's Circus, Battersea, and became involved in aeronautics, in which they became successful by accepting a commission to construct a helicopter for an Italian, a Signor Capone. Howard moved to 29 Lyford Road in 1909 to be closer to his Battersea works when the firm began taking substantial orders; Warwick lived at 8 Henderson Road, nearby.

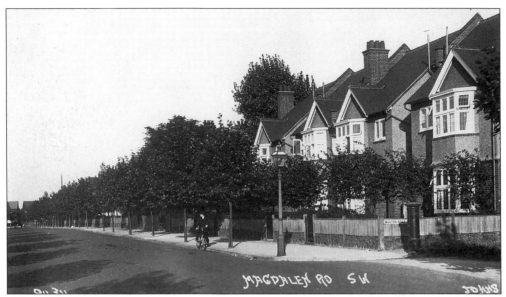

Magdalen Road, *c.* 1926. In 1926, Alderman William Edward Buchanan lived at 'Oriel', a large house next to his works of monumental masons and funeral furnishers which was next to Wandsworth cemetery, founded in 1878 and covering thirty-four acres. In the seventeenth century, Oxford University owned the Springfield estate in Burntwood Lane and in 1868 the suggestion was taken up that the road be named after Magdalen College, in honour of the University.

Melody Road, *c.* 1905. With a road name such as this we would expect at least one music teacher, and in 1922, living at number 102, was a Miss A.M. Ulrich—teacher of the pianoforte.

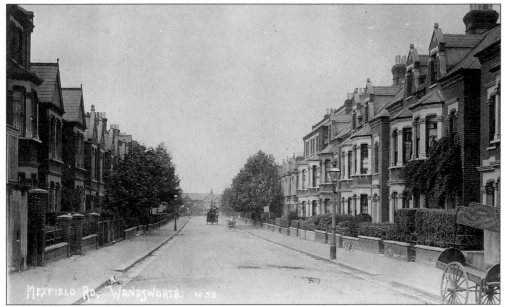

Mexfield Road, *c.* 1906. At the end of the First World War the West Wandsworth branch of the Soldiers and Sailors Help Society was based at 21 Mexfield Road, with Miss E. Tudor as the Honorary Secretary. During the 1930s the building also housed the Wandsworth and Putney branch of the Invalid Children's Aid Association. Number 18 was destroyed on 17 October 1940, the same night that Cromford Road was struck.

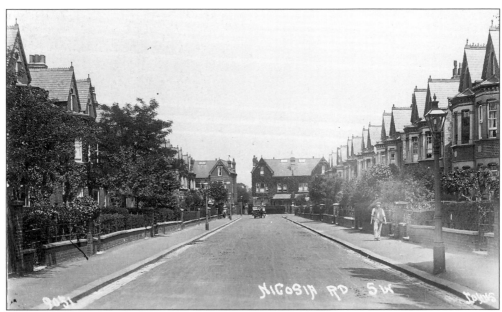

Nicosia Road, *c.* 1914. This road was built at a slower pace than some others being constructed at that time in Wandsworth. A Mr J. Hutchinson was erecting two properties for each year between 1884 and 1885, with a sudden increase to four houses in 1886 and 1887.

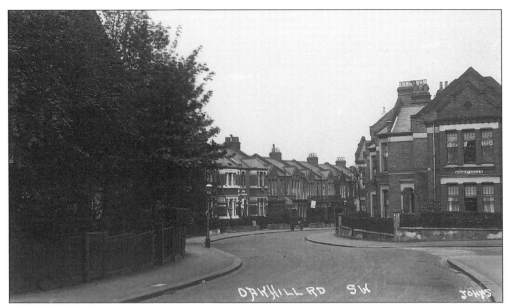

Oakhill Road, at the junction with Schubert Road, *c.* 1914. Alliott Verdon Roe's family, who originated from Manchester, decided to move to London during the 1890s and Alliott's father, Edwin Hodson Roe, a doctor, set up his surgery at 37 North Side, Clapham Common, later moving to 10 Oakhill Road, not far from the home of Dr Spencer Roe at 47 West Hill.

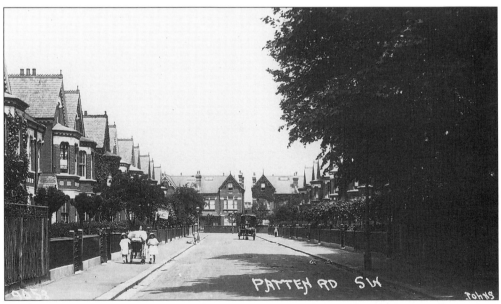

Patten Road, *c.* 1914. The houses in this road first appeared in 1884, when a Mr J. Duncannon gave notice of his intention to erect five pairs of private dwellings. In 1886 this was followed by a further five pairs. Increase in private ownership of motor cars is indicated by the erection of a 'motor shed' at number 19 for Mr John Hurstin in 1912, and a motor garage at number 22 in 1919.

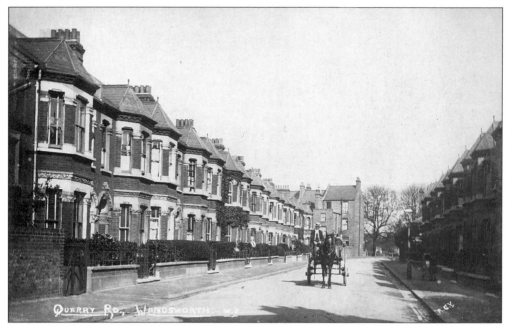

Quarry Road, *c*. 1907. The developer of properties in this road evidently wanted to see his investment back quickly, for he was to erect nine houses on the North Side in 1894 and the remaining nineteen in 1895.

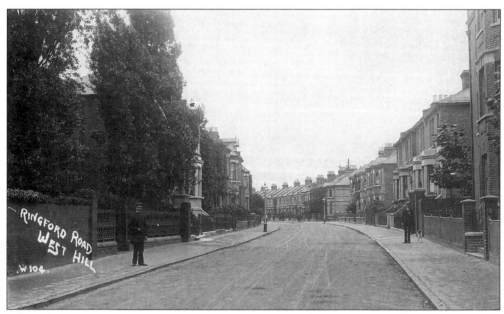

Ringford Road, *c*. 1907. This is a road whose buildings exhibit the different fashions of architects. A delay is shown between approval in 1869 and the erection in 1877 of one house each for a Mr W. Bennett and a Mr J. Price, who erected four more the following year. Nine were built in 1879, one in 1880, and others followed up to 1887. The road was completed with a flourish in 1898 with an application for one hundred houses; but this must have included some neighbouring streets.

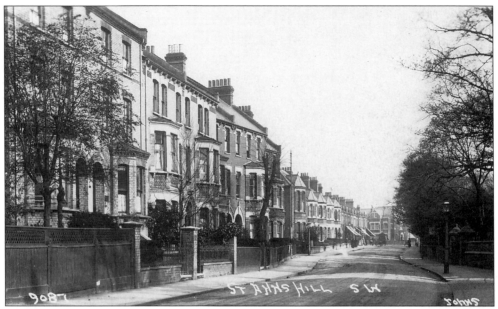

St Ann's Crescent, *c*. 1920. At the time this photograph was taken, the street had the name St Ann's Hill. This was given in 1863 following the building of St Ann's church. The LCC changed the name from 'Hill' to 'Crescent' in 1938 (see the following captions).

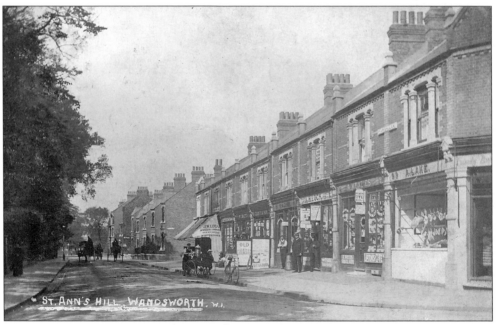

St Ann's Crescent as it is now known; when this photograph was taken, in 1906, it was St Ann's Hill. Here we have Mr Lake's butcher's shop, Menzies newsagents, H. Lock, jeweller and optician, and Mr George Lodge and Sons trading as corn chandlers, who also had another outlet at 73 Northcote Road, Battersea, between 1910 and 1917.

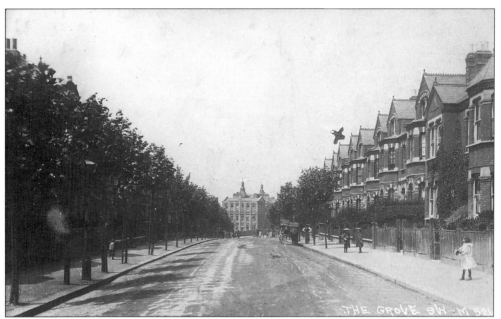

St Ann's Hill, *c.* 1906, originally called The Grove but encompassing two parades of properties with the names Vicarage Terrace (184 to 212), abolished on 1 July 1938; Glencoe Terrace (128 to 134), abolished 3 March 1933; and The Grove (139 to 229), abolished on 15 November 1937. The whole road became St Ann's Hill in 1936, which may lead to confusion for those tracing their family history.

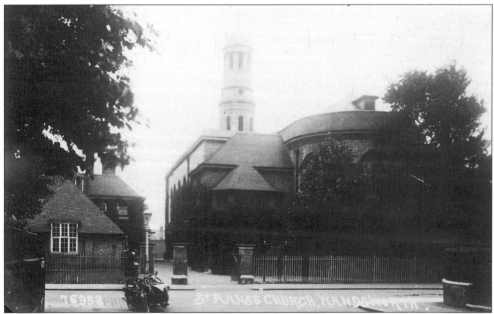

St Ann's church as seen from Rosehill Road, *c.* 1930. Built in 1822 to the designs of Sir Robert Smirk, who also designed the British Museum, the church was consecrated on 1 May 1824. The chancel was added in 1896 and with its tall, rounded tower, it is often referred to as the 'pepper pot' church. The church was badly damaged by a V1 flying bomb in 1944, and was fully repaired after the war.

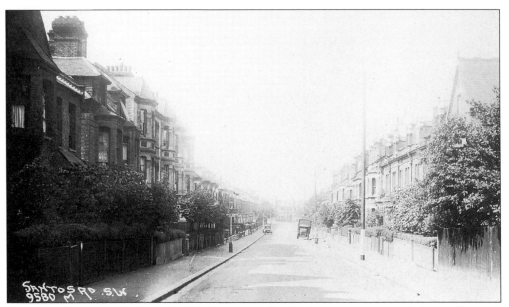

Santos Road, *c.* 1928, built on land belonging to the Rucker family who traded in coffee from the South American family of Santos Dumont of Brazil. His claim to fame is being the first person in Europe to fly an aeroplane, which took place on 13 September 1906.

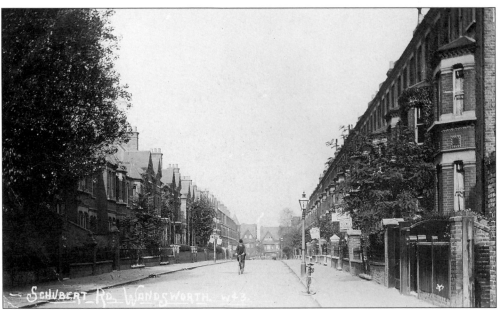

Schubert Road, seen here in 1908, probably received its name in honour of the German composer Franz Schubert (1797–1828). Development here was rapid, with permission for sixty-one properties being sought in 1884, one villa in 1886, and completion with four private houses on the West side in 1889. Mrs Verdon Roe's orphanage for forty-two girls was at numbers 65 and 67 in 1914.

Spencer Road on the borders of Wandsworth and Battersea, seen here in 1907, recalls the family name of Spencer who bought the title to both manors in the eighteenth century. By the 1830s, however, they had begun to sell off the land due to financial problems. Spencer Road, for instance, was given LCC approval in 1869.

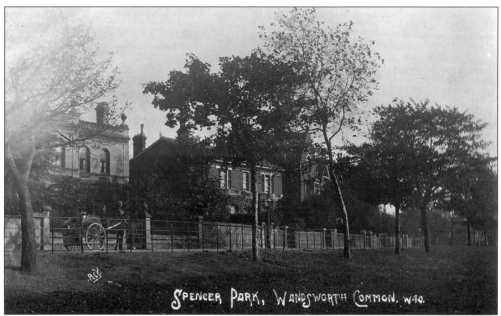

Spencer Park, c. 1908. The Principal of St Andrew's School for Girls at 47 Spencer Park was a Miss Elspeth Cameron McGregor, whose home was at 125 Lavenham Road, Southfields. Born in Dublin in 1863, she had lived in Wandsworth for sixty years when she died on 2 March 1942, and she was buried in Wandsworth cemetery. The school was converted into flats c. 1931 and named Spencer Court House.

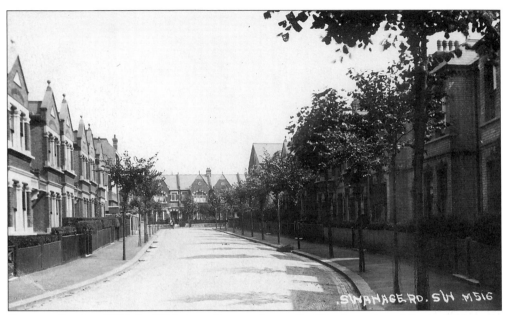

Swanage Road, *c.* 1906. In 1922 the collector of taxes for Wandsworth and Springfield wards, Charles Richard Long, assessed the taxes and returns from 35 Swanage Road. Bricks and mortar came in small doses throughout a period which started in 1891 and did not end until 1903.

Trefoil Road, *c.* 1906. A change from some other developments taking place in Wandsworth at the time was the proposal for the erection of all fifty-four properties in 1893 and 1894.

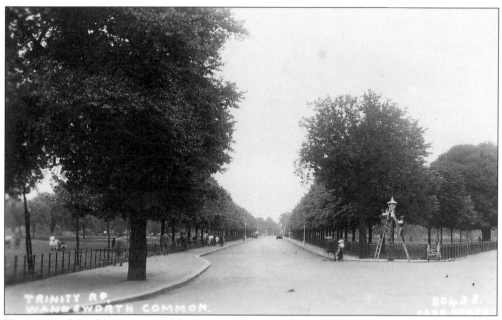

Trinity Road, at the junction with West Side, about 1928, with two council employees busily painting a street gas lamp. It was originally known as Wandsworth Lane, but after Holy Trinity church was opened in 1855 more people were heading towards 'Trinity' than 'Wandsworth' and the name was changed in 1879.

Trinity Road, c. 1912. This scene was altered dramatically during the 1960s, with the doubling in width of the railway bridge and the road. Earlsfield Road is to the right and Windmill Road to the left, just beyond the ice cream seller. The horse and carts are on the rail bridge.

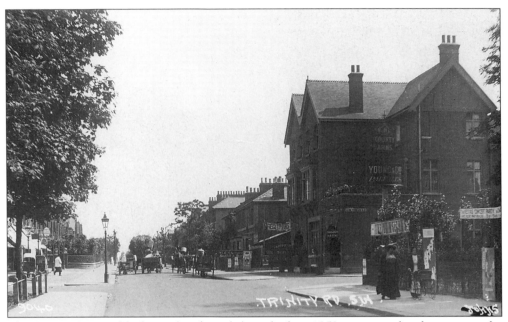

The County Arms public house (on the right) was built in 1852, one year after the prison to the rear of the pub. The present style of building dates from a rebuild in 1890. To the far side in this view dating from 1912 was the motor engineers Gunbie and Co., and the near side was occupied by the extensive nurseries of Neals, now relegated to a smaller nursery and shops in Heathfield Road, nearby.

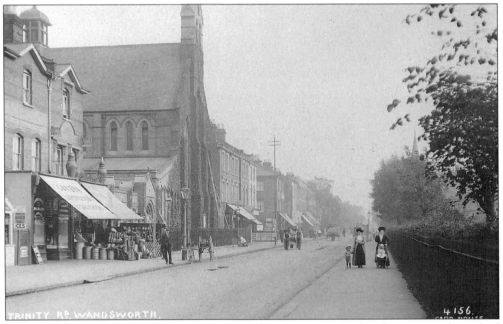

St Mary Magdalene church was almost a year old in this view, the foundation stone being laid in June 1907. Among the shops was the premises of Gordon Samuel, tobacconist, and the ironmongers and oil shop of F.H. Kerry and Son, where Pratts petrol was available.

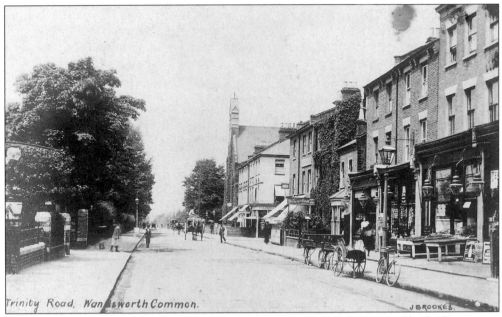

Trinity Road, Wandsworth Common. J BROOKES.

The small parade of shops in Trinity Road. In 1908 they included: George Charles King, corn chandler; Miss Weavers, draper; Frederick William Miles, piano teacher; Austin and Son, photographers; The National Telephone Co. Ltd; Frederick Dabbs, fruiterer, John Brooks, stationer; and Mrs Cole, fishmonger.

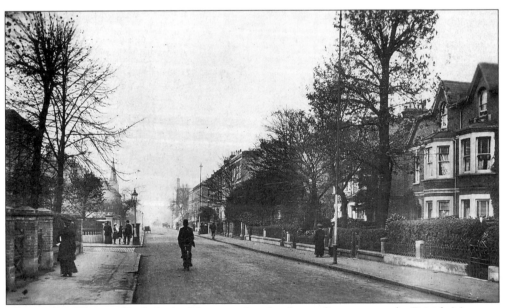

The novelist Thomas Hardy had a lifetime ticket for the reading room at the British Museum, which bore the address 1 Arundel terrace, Tooting. Later renumbered as 172 Trinity Road, the house bears a plaque stating that Hardy lived here from 1878 to 1881. The original blue enamel sign, 'Arundel Terrace', still survives.

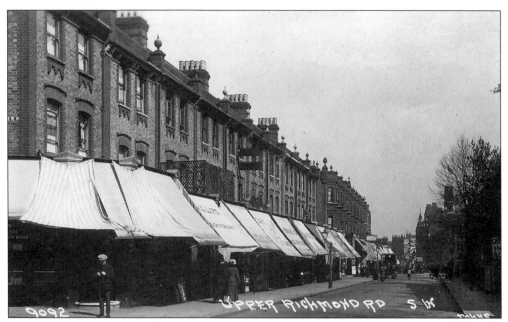

Upper Richmond Road, *c.* 1914. Every shop's blind is rolled out to protect the goods on display in this south-facing parade. In the mid-sixteenth century the fields here were called Hermitage Shott, probably because a hermit lived on this major land route to the royal palace at Shene and the West Hill route to Kingston, which was an ideal place to gain alms from merchants when they were on their travels.

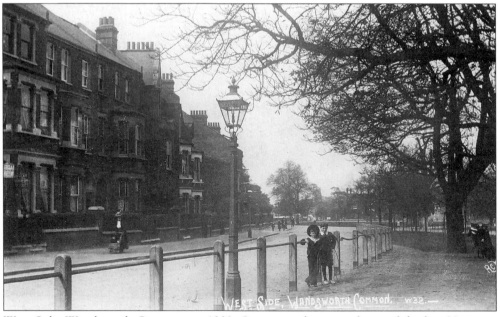

West Side, Wandsworth Common, *c.* 1908. One unusual aspect of part of the late Victorian development in this area was these three-storey properties, many of which were occupied by architects and surveyors or doctors and surgeons.

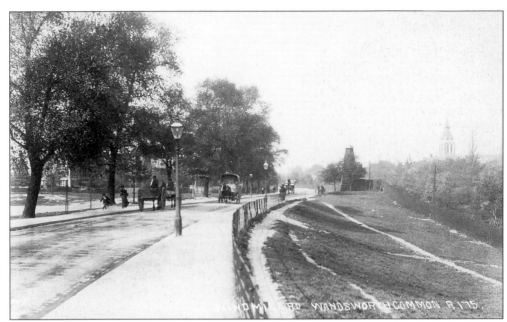

Windmill Road. Both photographs date from 1907. The road received its name from the small windmill built in 1837 by the London and South Western Railway which supplied water to local land users. The water was used to fill a lake on the Common, called the Black Sea, which is now filled in and covered by Spencer Park and the houses in Windmill Road. All of the many mills on the Wandle or the Thames waterside that powered the industries for which Wandsworth was famous have disappeared except this lone survivor of a form of 'free' power.

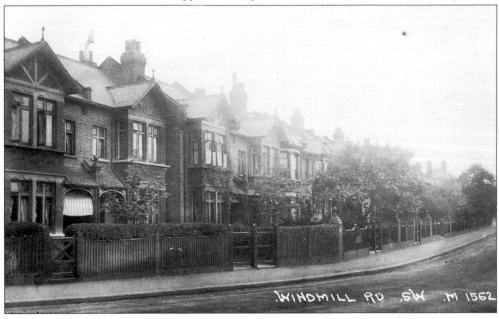

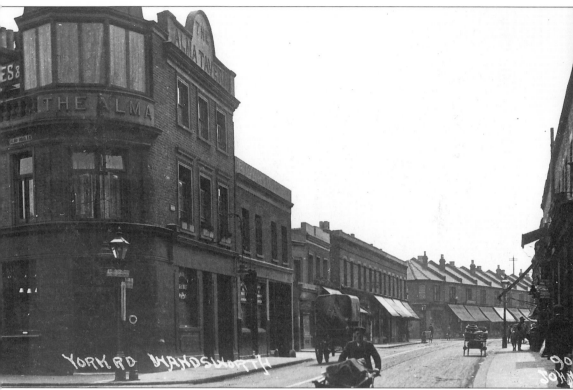

The Alma public house, York Road, *c.* 1914, which was built in 1866 and named after the Battle of the Alma which took place in 1854, during the Crimean War. Rare painted glass work, installed in the 1880s, still survives and Young and Co. have carefully restored many other decorative features within the building. The road is now called Old York Road, which is puzzling because the Archbishop of York's fifteenth-century London property which used to stand at the junction of Plough Road and York Road never had the prefix 'Old'.

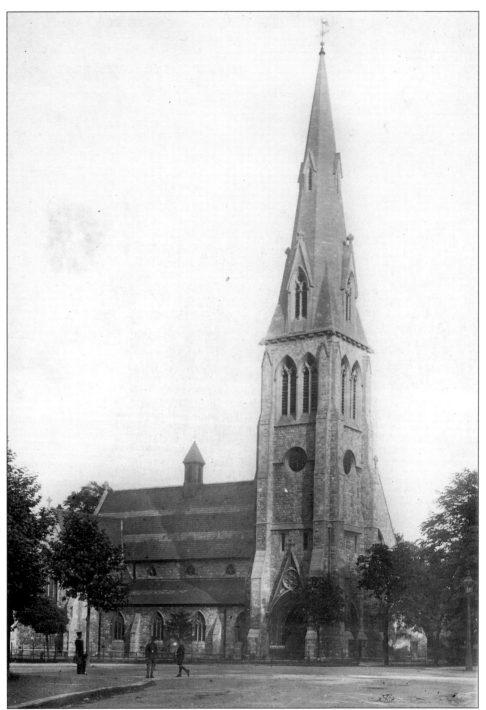

Holy Trinity church, West Hill, designed by the architect J.M.K. Hahn, was consecrated in 1862 and the 150-foot tower and spire was completed in 1888. Various stained glass windows were damaged during the Second World War and repaired in 1954. The sound of the bells rings out for some distance due to the imposing position of the church on the upper reaches of West Hill.

Seven

Earlsfield

Burntwood Lane, c. 1912. An early mention of the lane occurs in records dating from 1639 when Edward Cripps, brewer, and John Blake, husbandman, both of Wandsworth, purchased all wood except living trees and removed it at the price of £3 4s an acre. The name probably recalls the method of forest clearing for arable land during the Anglo-Saxon or early medieval period—or, as a method of tree and gorse management, pollarding of trees can include the burning off of undergrowth and fallen branches.

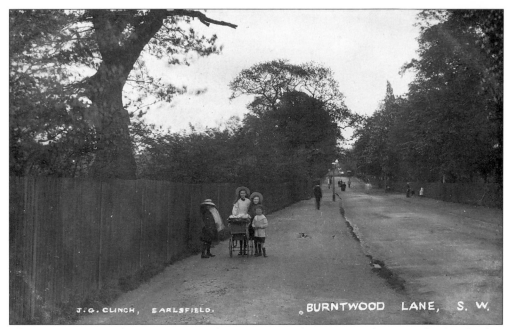

These two pictures taken in Burntwood Lane capture the transition between the farmland of 1907 (above) and the addition of housing in 1912 (below). The Holloway Brothers advertising board proclaims that land was available for building purposes on the Magdalen Park estate.

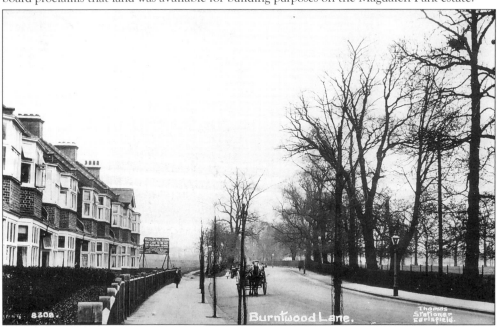

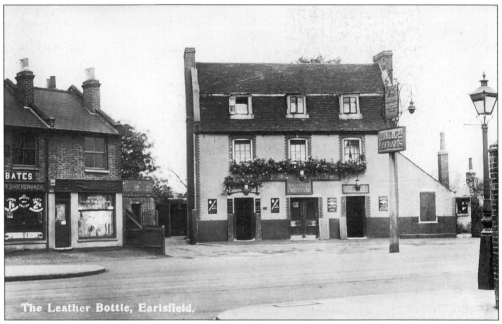

The Leather Bottle public house, Garratt Lane. This pub is the last remaining building of the small hamlet of Garratt which consisted of about fifty houses. The pub was first mentioned in 1745, but is probably older. It gained fame between 1747 and 1796 when over 100,000 people would gather here—jamming the roads for miles around—for the mock election of the mayors of Garratt. A small revival in 1826 failed due to lack of funds from local publicans and lack of wit among the contestants.

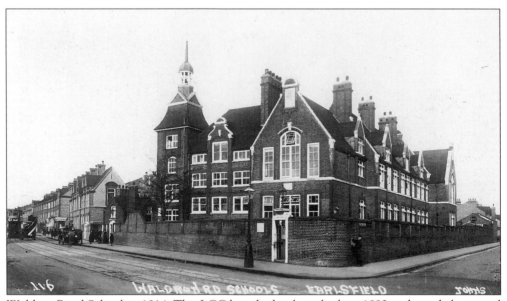

Waldron Road School, c. 1914. This LCC board school was built in 1892 and stood alone until the private houses in the street were built, between 1906 and 1913. The school was destroyed by a direct hit from a high explosive bomb on the night of 17/18 October 1940. Garratt Park special school now occupies the site.

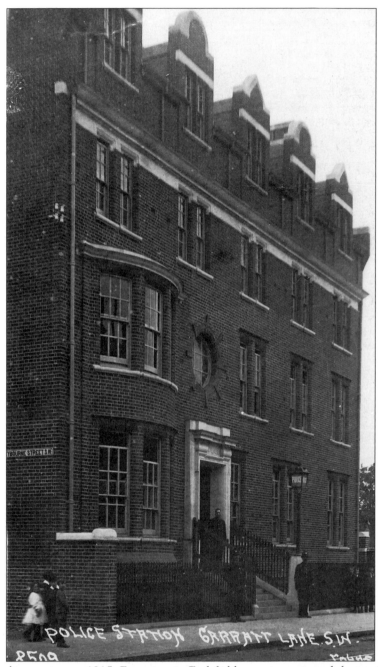

Earlsfield police station, *c.* 1915. Four sites in Earlsfield were investigated during 1912 before the freehold on the present site was purchased on 1 November 1912 from Mrs E.E. Hardman and Mr A.E. Boyce. The doors were officially opened on 31 August 1914. The station had space for sixty men on duty with accommodation in the section house on the top floor for thirty single men and one married inspector. Rent was one shilling per week for single men's accommodation and ten shillings for the married quarters. An ambulance was stationed on the premises, and the divisional doctor appointed for five years was Dr J.T. Thyne of 101 Earlsfield Road.

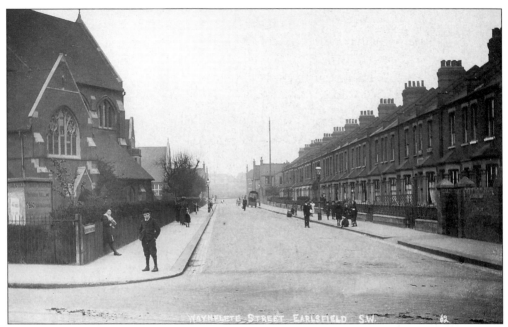

Wayneflete Street *c.* 1908. St Andrew's church is on the left; in the distance is Tranmere Road, and beyond are allotment grounds and fields planted with vegetables.

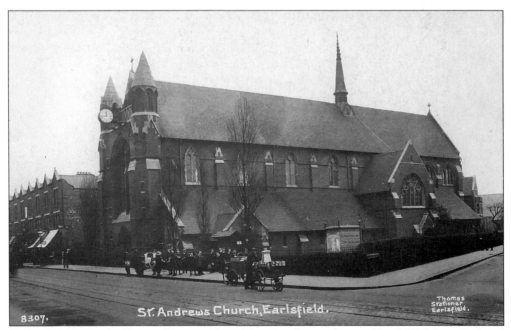

St Andrew's church, Garratt Lane, *c.* 1912. The church was designed by E.W. Mountford and building began in 1889. The chancel, south chapel, and the three bays of the nave were consecrated on 8 November 1890. It was built by William Johnson & Co. The remainder of the church was consecrated on 1 March 1902. The clock was unveiled by Sir Henry Kimber, MP, on 8 February 1911 in memory of King Edward VII.

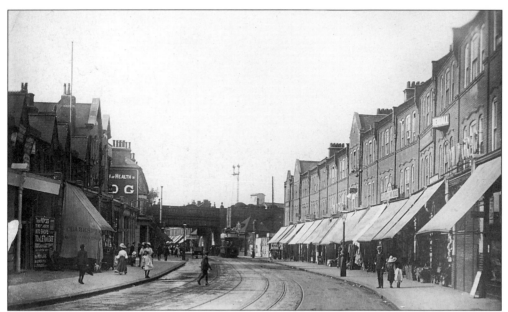

Garratt Lane, *c.* 1909. Many of these shops were built in the 1890s, but a few, such as those on the left of this view, were converted from private houses as late as 1910.

Swaby Road, *c.* 1925. Eighty-one properties were built in 1907 but to provide housing after the end of the First World War the Council agreed to the development of twenty-four acres of the Magdalen Park estate, comprising 376 houses which were then purchased by the Council. Construction work started in January 1920 and the estate was completed in May 1923.

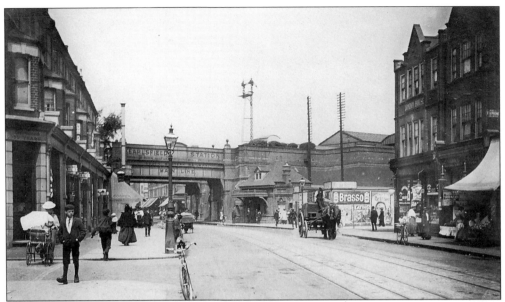

The steam railway line was built by the London and South Western Railway Co. and it opened in 1838, but it was not until property development was under way that the company, on doubling the tracks to four lines, opened the station on 1 April 1884. The station, pictured above in 1910, had the name 'Earlsfield and Summerstown' until before the First World War. In the lower picture is a LSWR Waterloo to Portsmouth express passing the down platforms in 1910.

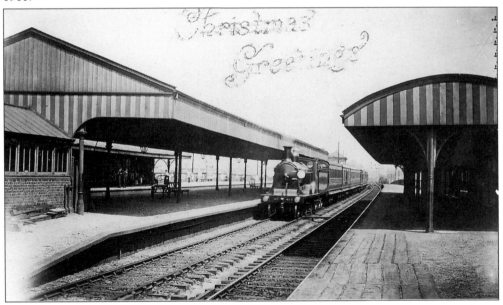

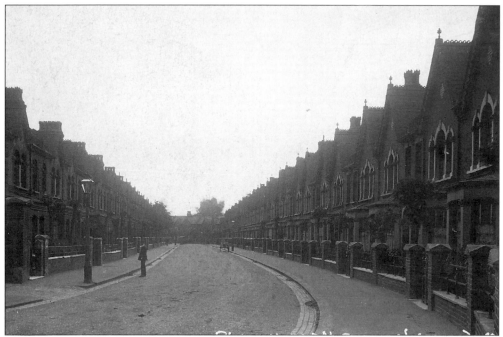

Summerly Street, *c.* 1914. Although a mainly residential road, commercial activity after the First World War included the Earlsfield Foundry and Engineering Co. and a farrier, Mr Charles Byatt, trading from number 54. The Acme Patent Ladder Co. had their workshop at 51a.

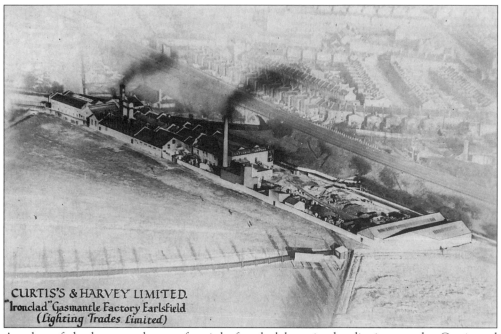

CURTIS'S & HARVEY LIMITED.
"Ironclad" Gasmantle Factory Earlsfield
(Lighting Trades Limited)

Another of the large employers of mainly female labour in the district was the Curtis and Harvey ironclad gasmantle factory, just off Ravensbury Road, seen here from the air about 1925. Made from silk, the mantles had to be dipped in collodian and dried. The smell got onto the girls' clothes and they would be known by the odour they gave off.

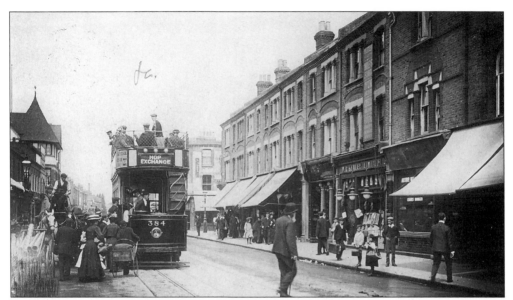

The LCC introduced the electric tram service, with an average speed of $9\frac{1}{2}$ miles per hour, along Garratt Lane in 1906—the previous service being a horse-drawn bus from Walham Green to Tooting run by the Star Omnibus Co. Tram car number 384 was a 'D' class with 66 seats, seen here in about 1909 before being rebuilt with a covered roof and balcony ends. The no. 612 trolleybus to Mitcham fair green took over the route on 12 September 1937.

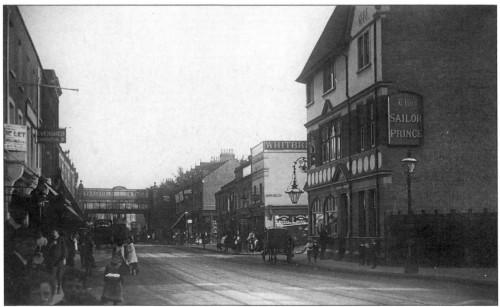

The junction of Garratt Lane and Penwith Road, about 1910. The Sailor Prince public house (on the right) was only licenced as a beer house during the 1870s and the building seen here was erected in 1887 as The Sailor Prince Hotel. King Edward VII's second son, the Duke of York, born in 1865 and later to become King George V, was a keen sailor and served in the Royal Navy.

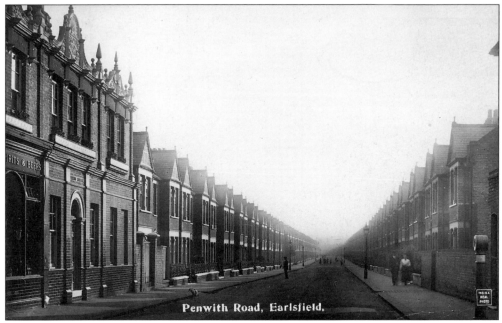

Looking east along Penwith Road about 1912, on the left is the off licence built in 1900 and run by Frank Laceby. It is now the Pig and Whistle public house.

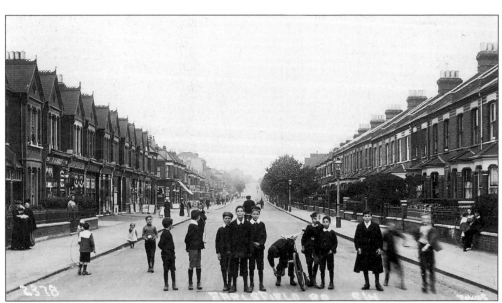

In 1876, Robert Davies purchased fifty-nine acres of land to add to his existing properties, which then totalled 100 acres. His intention was to build 300 of the larger properties in Earlsfield Road with forty-foot frontages. Selling for £1,000, they were similar to those surviving on the upper reaches of the road. Smaller properties set in terraces, as seen here in 1912, were more rewarding as they could be let more quickly.

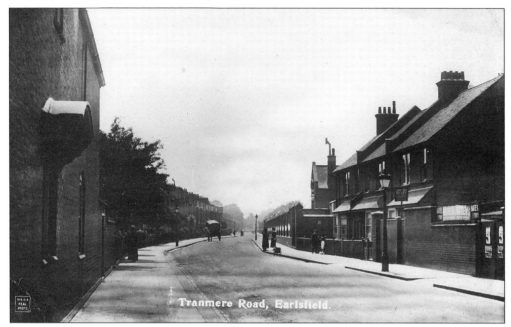

Tranmere Road, looking south from Magdalene Road about 1918. This was a 'young' road for Earslfield, as the majority of houses were erected between 1901 and 1905 with the addition of eleven properties in 1926. Ernest Fry, councillor for Springfield ward in 1922, lived at number 20.

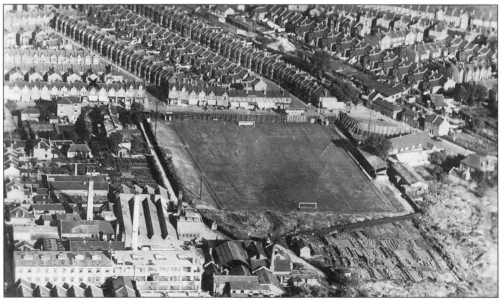

Summerstown football ground from the air, c. 1925. These ten acres were acquired by the council to erect 272 flats. The estate was opened on 30 May 1938 by Sir Walter Elliott MC, MP, Minister of Health. The Henry Prince estate was named as a memorial to Henry Prince JP for his services to the Council. He was Chairman of the Housing Committee from 1919 to 1936. In the foreground is the factory of A.A. Hunt Ltd, Capacitors, makers of radio components.

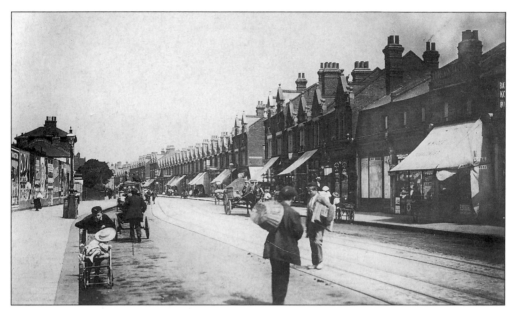

The Summerstown football ground is behind the hoardings on the left, now occupied by the Henry Prince estate. Atheldene Road is to the right, beyond the horse and cart, which was competing for road space here in 1910 with several small hand-pushed delivery vehicles.

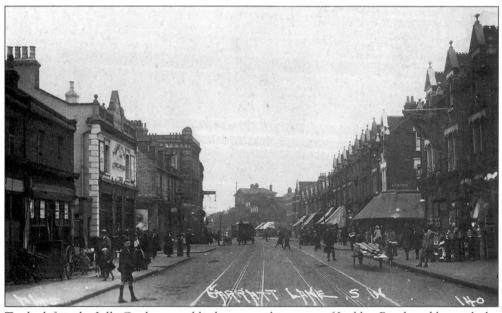

To the left is the Jolly Gardeners public house on the corner of Lydden Road, and beyond, the Grosvenor Arms public house on the corner of Wardley Street, seen here c. 1912. Hope's oil shop at numbers 311 and 313 sold a variety of household items: zinc baths and buckets, ladders, mops and linoleum, all displayed on the pavement or hanging from the shop front.

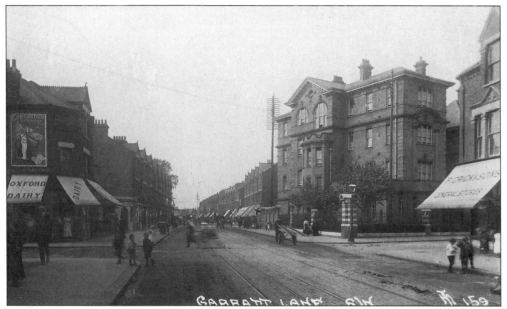

The junction of Swaffield Road and Guelph Street, renamed Kimber Road after Sir Henry Kimber, Conservative MP for Wandsworth from 1885 to 1913, who at one time lived at Park Villa, 22 Wimbledon Park Road, and also at Lansdowne Lodge, West Hill. The date of this scene is between June and October 1911, for the Coronation Exhibition banner above the Oxford dairy on the left was in honour of the coronation of King George V.

Earlsfield House, seen here in 1911, was built between 1903 and 1908 as the Wandsworth Union Intermediate School, and it was so used until 1930. Between 1931 and 1953 the LCC used it as a children's receiving home. The LCC then used it as a reception centre for boys under the age of twelve who were on remand. In 1964 Wandsworth Council took it over, and it finally closed in 1981. The house is now converted into private flats.

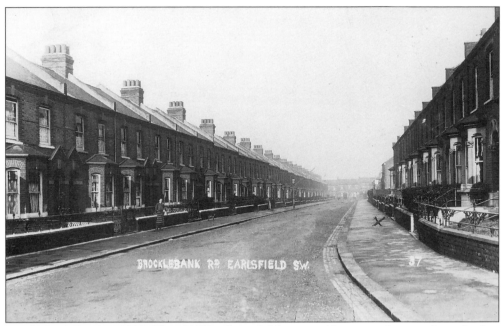

Brocklebank Road, *c.* 1910. The old Wandsworth Union workhouse used to stand nearby, but has now been demolished. The present health centre, fronting onto Garratt Lane, has been given the name Brocklebank.

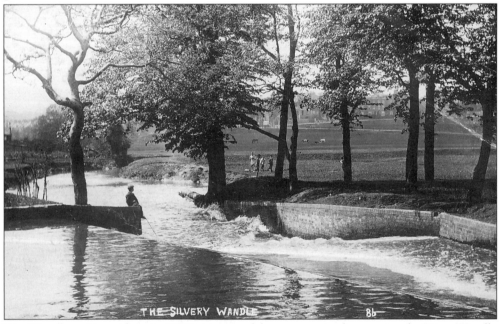

The Wandle weir, seen here in 1910, was part of the water control system on the River Wandle for McMurray's paper mill that stood in Garratt Lane opposite Iron Mill Place. In the early nineteenth century the mill was known as Henkell's iron mill, when it was forging and drilling cannon for use during the Napoleonic wars. Beyond the trees, young boys are dressing after a swim and beyond is the the open field—where cows are grazing—that became King George's Park. Buckhold Road and Merton Road can be seen at the far end of the field.

Eight

Southfields

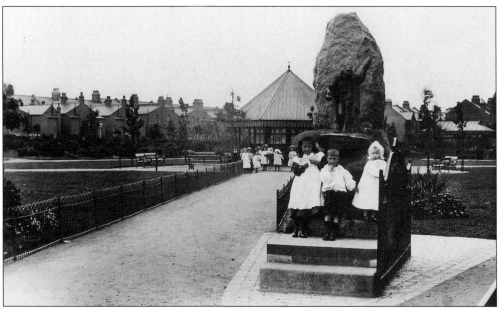

The two acres of the Coronation Gardens in Southfields alongside Merton Road School were bought by Sir William Lancaster, Mayor of Wandsworth 1901/2, and presented as a park to the people of Southfields and also as a memorial to the coronation of King Edward VII in 1902. The fountain was presented by William Lancaster's sisters in honour of his term in office.

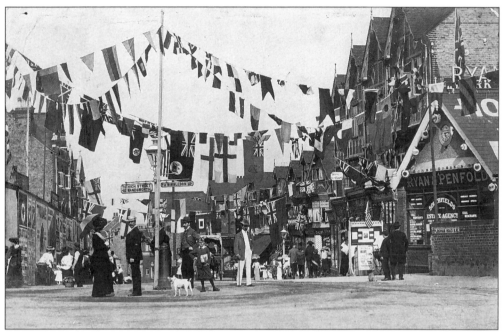

Replingham Road, bedecked with flags and bunting on 13 July 1905 to welcome Princess Christian of Schleswig-Holstein, who was to open the Southfields children's flower show, held on the Wandsworth technical college playing field between the railway and Wimbledon Park Road. The Mayor, Alderman J.H. Anderson, and the Council in State welcomed the Princess, and members of the 4th Volunteer East Surrey Regiment (from St John's Hill) formed a guard of honour. Princess Christian (1846–1923), the daughter of Queen Victoria, was christened Princess Helena.

Southfields from Arthur Road c. 1910 with the tower and spire of Holy Trinity church, West Hill, on the horizon. The green fields now form part of Wimbledon Park, and the spot where Elsenham Street meets Melrose Avenue can be seen on the right, with houses in process of construction.

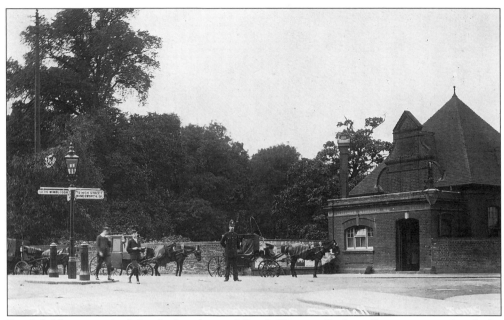

Southfields station, built by the London and South Western Railway Co., was opened with the line from Putney to Wimbledon in June 1889, which proved expensive to construct due to the amount of demolition required at the north of the line. Steam engines ran on the service until electrification in 1905. Both views, of the station and the train to High Street Kensington, are dated 1914.

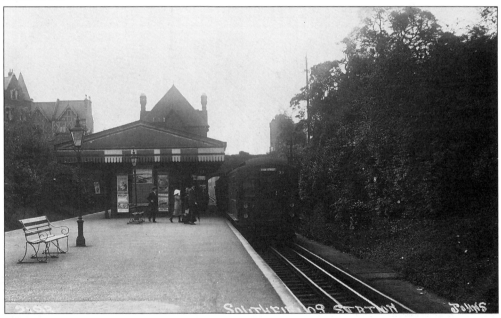

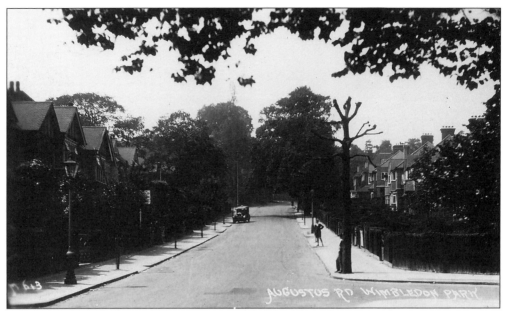

Augustus Road. The 1912 scene below was taken when only twelve properties were listed as being on the road, among them Coomb-Allen, Torwood Cottage, and Struan. The above view, dating from about 1933, is near the corner of Sutherland Grove, when many of the larger properties had been broken up and semi-detached houses built in their place.

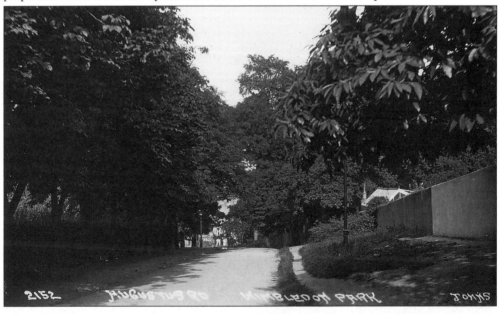

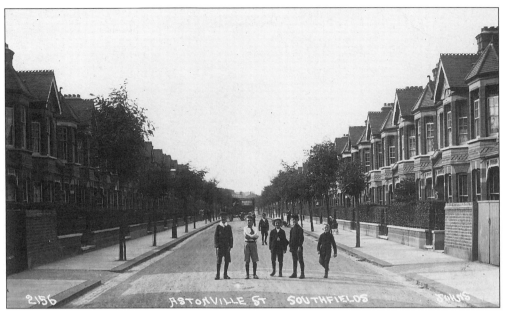

Astonville Street (above), seen here in about 1914, was mainly built over the years 1904–6, with the earliest construction being only two properties in 1898. The sub-post office on the corner of Revelstoke Road, seen here about 1930, also sold a range of stationery. A former resident at number 61 was Mr William Henry Rogers who, although blind, taught handicrafts in Virginia, USA, in 1957

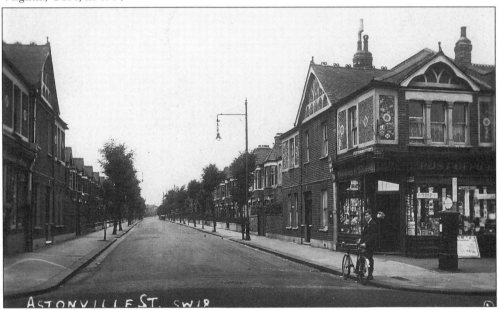

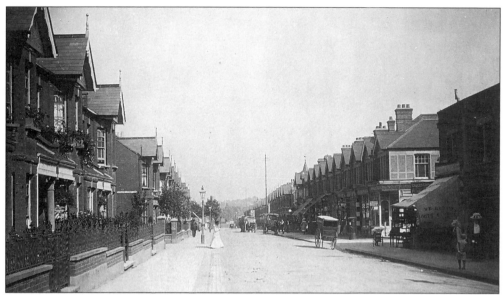

Brockwood Road with Engadine Street on the left, *c.* 1910. Between 1896 and 1901, house-building was the main preoccupation of developers, with the first shops going up in 1901 and a mix of shops and houses in 1903 and 1904. From 1907 onwards the conversion of former houses into shops was taking place mainly between Clonmore Street and Heythorpe Street.

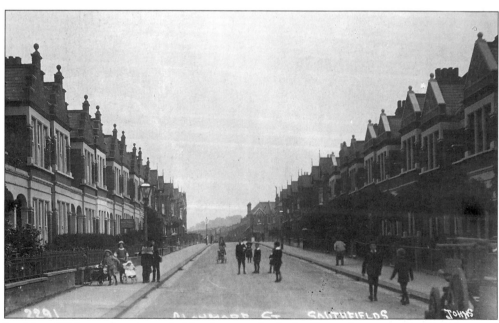

In May 1914, at the time of this photograph, Lady Tenterden opened a holiday and convalescent home at number 11 for the children of distressed gentlefolk, so that children could have a holiday and a change of air.

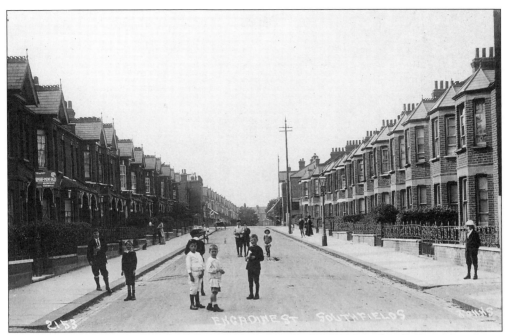

Engadine Street, *c*. 1914. Twelve houses were constructed in 1895, with a further twenty-nine properties being built in 1901. The first shop, a bakehouse on the corner of Lavenham Road, was laid down in 1901, with the other shops from 1904 onwards. The road was completed between 1905 and 1910.

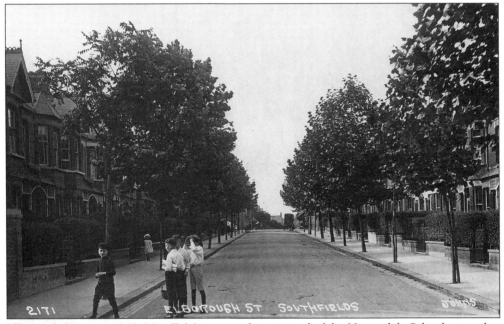

Elborough Street, *c*. 1912. Miss E. Mason was the principal of the Homesdale School at number 63 in 1912. Mr Thomas Leppard, who died on 11 February 1942 aged eighty-two, had started work sixty years previously and was well-known in Wandsworth for his chimney sweep's business which operated from 92 Alma Road. He lived at 3 Elborough Street.

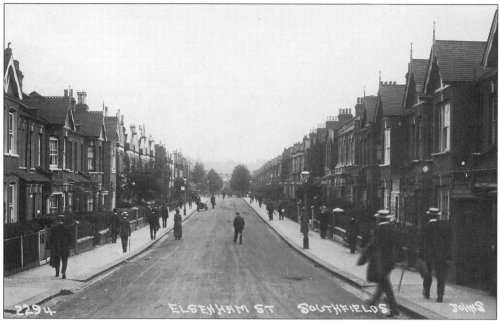

Elsenham Street, with a great number of people walking down from Replingham Road during the summer of 1912, shortly after an underground train had disgorged its passengers at Southfields station nearby at the end of a working day.

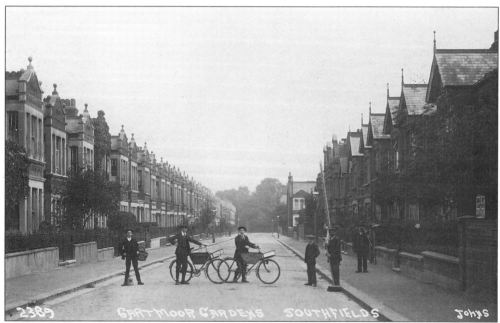

Delivery boys standing in Gartmoor Gardens during 1912, with the cycle on the left coming from G.W. Simmonds, fruiterer and grocer at Station Parade, Southfields, and the other bike from Austin Willis & Co., a large drapers store in Replingham Road. The two gentlemen on the right are road-sweepers, while the youngster on the left has a delivery basket in one hand and a paraffin can at his feet.

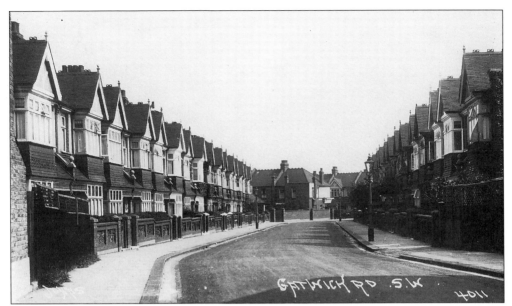

Gatwick Road, seen here in 1919, was developed in one fell swoop when twenty-nine houses were erected in 1910. The road is probably named after the small Surrey village and racecourse, six miles south of Reigate—now known, of course, for its airport.

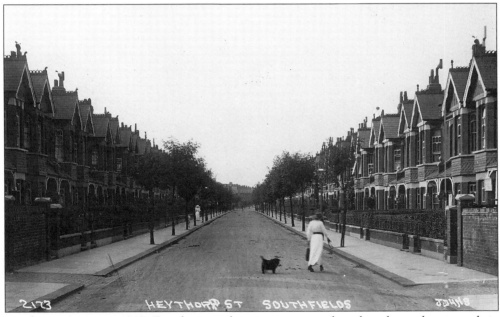

Heythorpe Street, c. 1912. Development here was protracted, with eighteen houses and six shops on the corner of Replingham Road laid down in 1895 and the majority of the rest of the properties dating from 1901–4. Living in Southfields during this period must have been noisy and messy, with deliveries of bricks and timber almost on a daily basis.

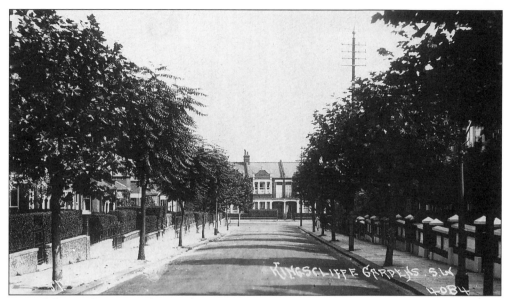

Kingscliffe Gardens, seen here some nine years after construction had been completed in 1903–4. The two earliest houses date from 1893, with several others being added in 1896 and 1897.

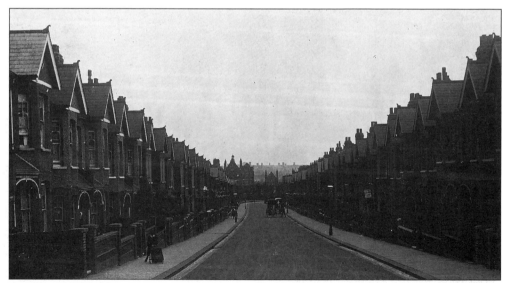

Another Southfields street given a Surrey town name is Pirbright Road, seen here in 1912. At the lower end of the road can be seen Merton Road School, with the forbidding towers of Wandsworth prison on the skyline.

Prince's Road, named in honour of the royal family but most particularly after Queen Victoria's visit to the London Rifle Association ranges on Wimbledon Common. Attempts to rename it Marina Road failed due to local protests, and it was left as Prince's Way in 1935. In the road was Allenswood, number 47, which was visited by Eleanor Roosevelt, wife of the US President F.D. Roosevelt in 1942. In 1957 her old school was compulsorily purchased by Wandsworth Council and it was demolished to make way for flats, called Allenswood, housing twenty-two elderly people. The house next door, number 49, North House and Lodge, was built in 1934 and was designed by Edwin Lutgens. 'Florys', the home of Alexander Glegg, Mayor in 1906, stood on the corner of Augustus Road; he died there on 19 March 1933 aged 86. Oaklands, a Catholic school of languages from 1930 to 1939, was demolished about 1968; a local authority housing estate erected in the grounds during 1951 and 1952 is called Oaklands.

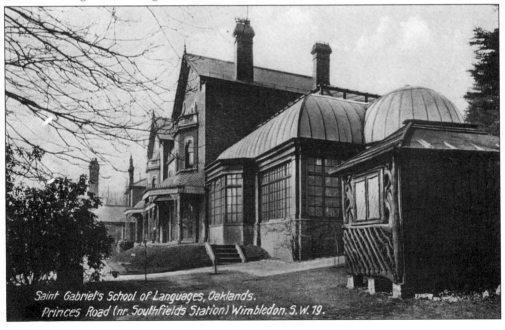

Saint Gabriel's School of Languages, Oaklands. Princes Road (nr. Southfields Station) Wimbledon. S.W.19.

After constructing the houses in Pulborough Road from 1907–9, Messrs Woodley Bros of 7–9 Pirbright Road, who had works in this road, produced the above view of numbers 27 and 29, advertising 'these charming houses for sale, freehold or leasehold'. By 1912, we see here that the young trees were beginning their push into the sky.

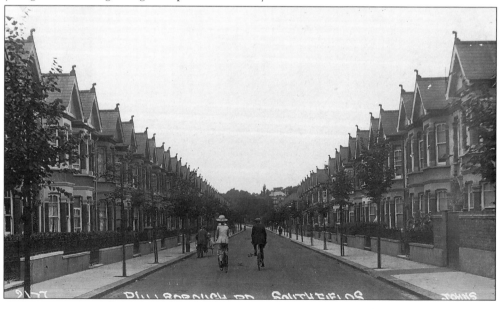

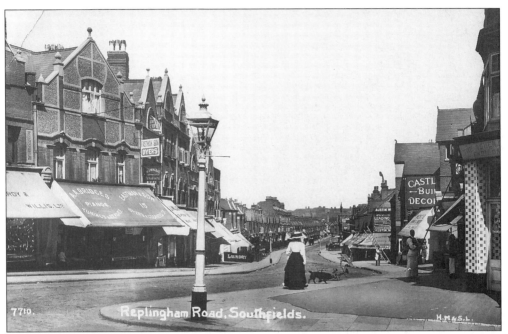

In 1910, Replingham Road was the hub of Southfields with the majority of shops near the station. In the above view is the shoe shop Freeman Hardy Willis, with number 15 next door to it being shared by A.A. Bridges, piano tuners and dealers, and Eastman and Son, cleaners and dyers. On the right is the Ashengrove Dairy and the gentleman with the pole is lowering the blinds on Hammett's butchers. The lower scene has Austin Willis & Co. on the right with George Matcham's tobacconists opposite and Thomas Cottman's chemists hiding behind the sun blinds.

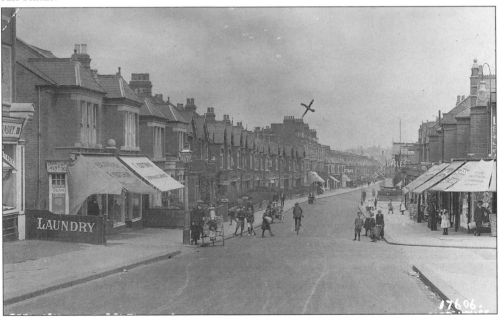

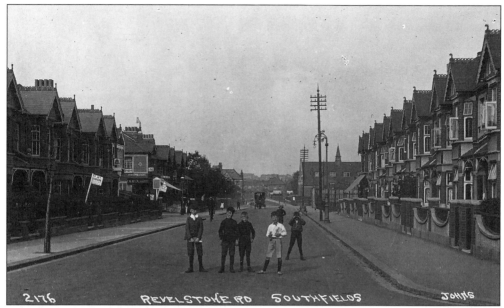

Revelstoke Road was named after the land's freeholder in 1903. In the upper view of about 1912 the earlier Methodist chapel on the corner of Ravensbury Road can be seen, which was replaced by the 1,600-seat Central Hall in September 1925 seen in the lower view, *c.* 1933. Here could be seen Elsie and Doris Waters, Arthur Askey, and also Flotsam and Jetsam. To see and hear the opera singer Eva Turner would cost a shilling. The hall was demolished in 1992/3 and a smaller church with housing units attached has since been built.

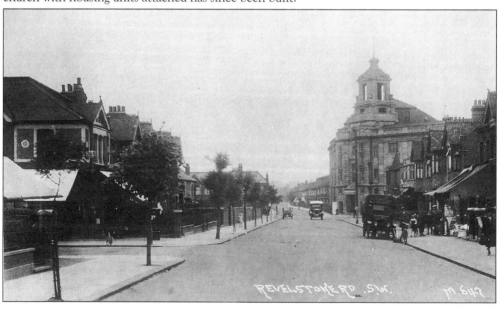

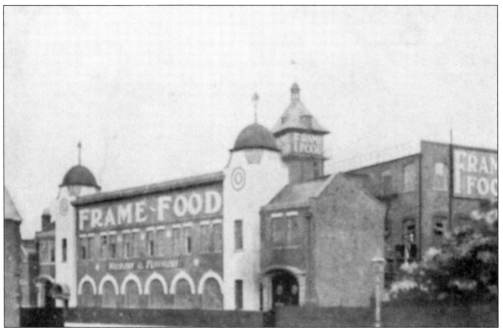

The Frame food factory in Standen Road was designed by W.T. Walker and the art nouveau decoration was styled by the artist Charles E. Dawson and erected in 1904. Frame Food moved here from a riverside location next to the rail bridge in Lombard Road, Battersea. An advertisement in the *Wandsworth Borough News* for 1905 proclaims the 'Life giving phosphates and albuminoids—babies cut teeth without losing sleep—a Frame food baby makes a happy nursery'. The building survives as Kingfisher House.

Singing the praises of FRAME FOOD

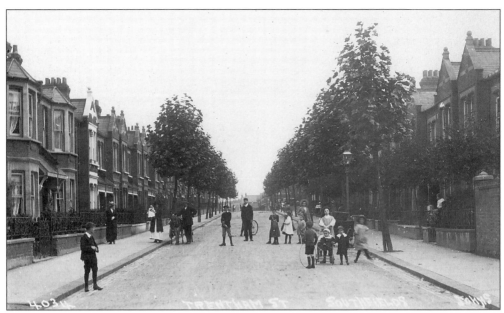

Both views are of Trentham Street in 1912. The majority of the houses were laid down in 1905 and the first known resident was a Mr Edwin Burton in 1907. The only thing for the children to beware of was the deposits left by the horse-drawn traffic.

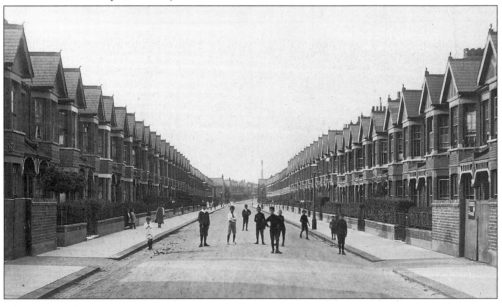

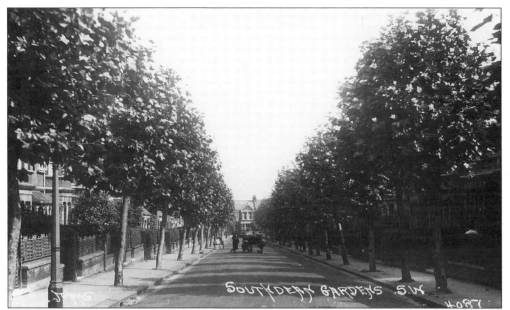

Southdean Gardens, c. 1912. Development started early here by Southfields standards, with thirty-six properties laid down in 1889 and the road gradually filling up to the year 1903, when a 'motor shed' was built at number 54—a set term for 'garage' had not yet been agreed upon. The Fellmongers Association of Great Britain and Ireland operated from number 24 in 1935.

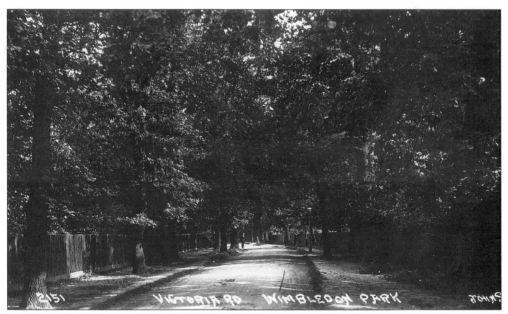

Victoria Road, now Victoria Drive, seen here in 1912 looking like a country lane. It had some large houses such as Oaklea, where the dowager Duchess Kintore lived; Fernwood, home of Sir Charles Elliott KCVO, LL, JP; and Urmstom Lodge, renamed Mains Lodge in 1921, home to the Twelfth Earl of Dundonald, KCVO, CB, a distinguished British general who saw service at Khartoum, in the Nile expedition of 1884–5, and in the South African war. The thirteenth Earl was living here in 1938.

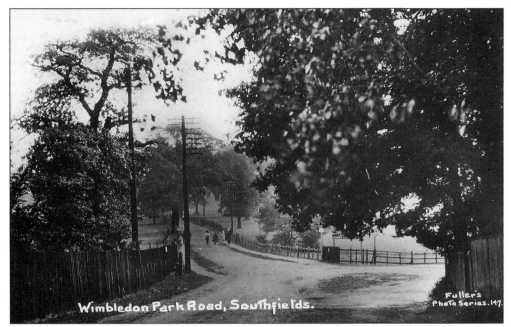

Wimbledon Park Road, with Bathgate Road and Albert Drive entering on the right, *c.* 1910. The Wimbledon tennis grounds moved to the field on the right, from Worple Road, Wimbledon, during the 1920s and it has remained there since. This road is a maelstrom of visitors and players every June.

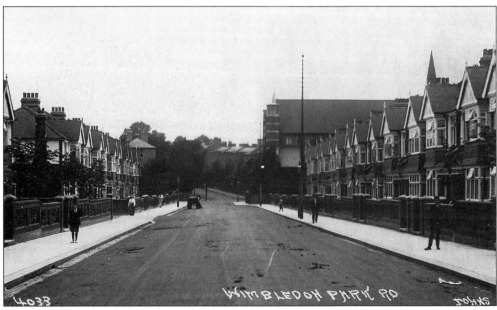

This part of Wimbledon Park Road was developed between 1905 and 1912, when this photograph was taken. The foundation stone of St Michael's and All Saints was laid on 10 April 1897 by Princess Mary Adelaide, Duchess of Teck, but the building was not completed until 1905. The architect was E.W. Mountford.

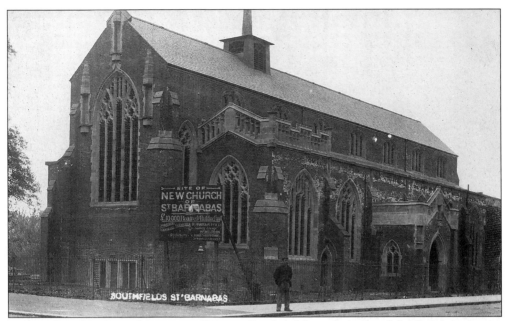

St Barnabus church on the corner of Merton Road and Lavenham Road. Its foundation stone was laid in November 1906, and it opened for services in 1908, when this view was taken. The architect of St Barnabus was Mr C. Ford Whitcombe. The Southfields war memorial, erected by public subscription, was consecrated on 4 October 1919. The church was damaged by incendiaries in 1941, and was not fully restored until 1955.

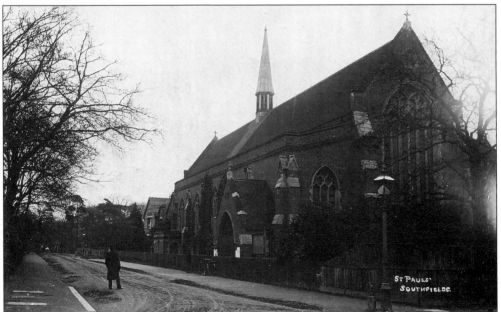

St Paul's church, Augustus Road, at the junction with Inner Park Road, c. 1910. A temporary church was erected here in 1877 and the present church commenced building in 1889. It was consecrated on 7 November 1896. The church was built by Somers Clark and J.T. Micklethwaite and it was awarded a preservation order as early as 1955. The altar from St Agnes', Kennington, was housed here after war damage and returned in 1958 after repairs.

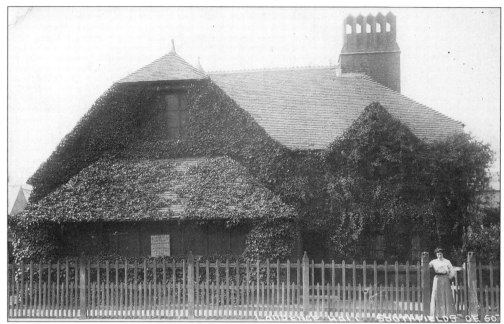

St Laurence mission hall, Standen Road, *c.* 1906. The hall stands next to the Southfields Club and opposite the former Frames Factory. The building was used as a refugee centre during the Second World War and has been an unofficial meeting house for early events and gatherings in Southfields.

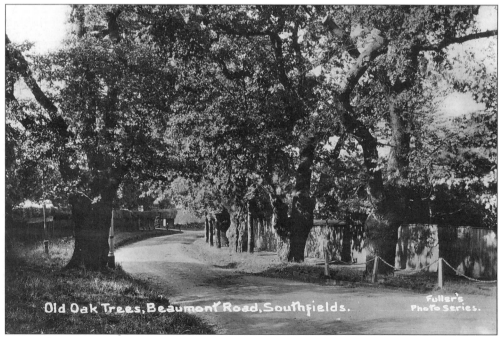

Beaumont Road, *c.* 1910. In 1925, the only properties listed from West Hill to Augustus Road were Glencaple, Lincluden, Thorpe Cottage, Woodhouse, Oak Lodge, and Fairview. Local authority housing has encroached on the area throughout the post-war period, and none of the above detached houses survive.

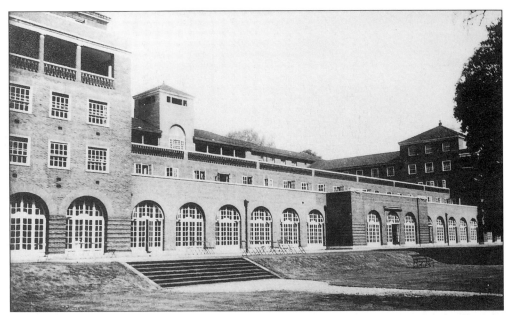

Whitelands College, which was founded in Chelsea in 1841 as a Church of England college for the training of women in elementary schools. The present building in Sutherland Grove dates from 1929–31, when the picture was taken, and it was opened by Queen Mary on 1 June 1931. Standing in $12\frac{1}{2}$ acres of ground, it was designed by Sir Giles Gilbert Scott RA, and has a chapel with interesting stained glass by William Morris. John Ruskin, the writer and painter, was the instigator of the May Queen ceremony for which the College is famous.

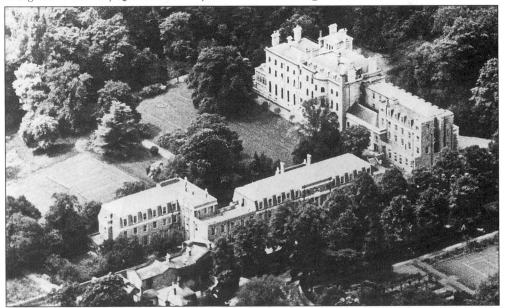

Southlands College, 65 Parkside and Inner Park Road. The Wesleyan teacher training college was in Battersea High Street from 1870, and it moved here in 1927/8. The building dates from about 1860, and between 1898 and 1911 the Duke d'Alençon lived here. Following him was the Duke de Vendome, who lived here until the college arrived in 1927. This aerial view was taken about 1930.

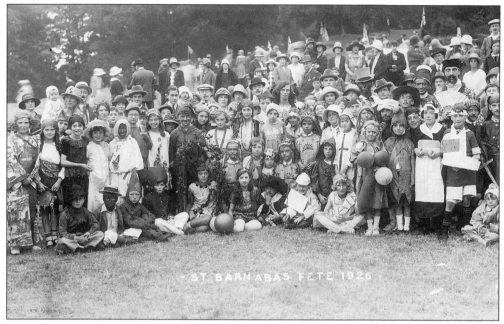

The St Barnabus church fête was held in 1925 at the Leg of Mutton field, which is now covered by the houses of Girdwood Road and Skeena Hill. Here are the many contestants for the fancy dress competition.

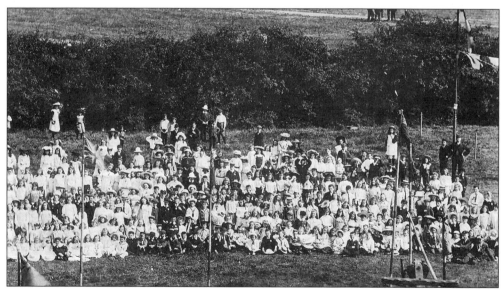

Exhibitors at the Southfields children's horticultural fête *c.* 1910. Originally held each July on the field between the railway and Wimbledon Park Road, the venue had to move with the advancement of building works and this event probably took place at the Leg of Mutton field.

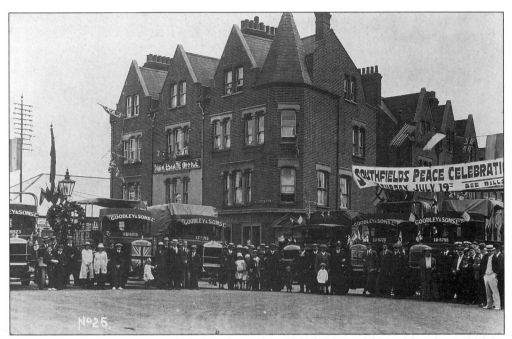

Saturday 19 July 1919 was the day set aside for the official peace celebrations at the end of the First World War. The Thornycroft lorries displayed here, near Southfields station, were part of the fleet of Goodley and Sons Ltd, who were based at 15 Replingham Road.

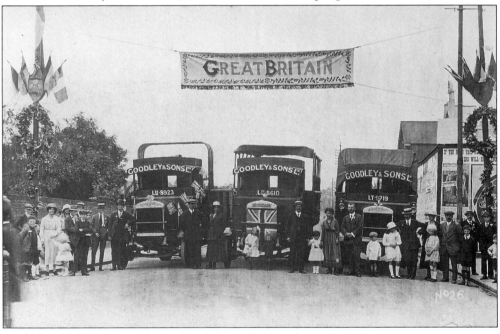

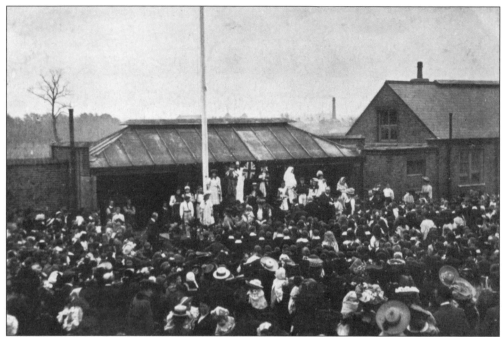

Empire Day celebrations, 24 May, which was also Queen Victoria's birthday. Here the celebrations are seen at Southfields School, where parents have accompanied their children in watching a tableau on an impromptu stage in the playground. A young girl holding a shield with the Union flag attached and dressed as Britannia appears above the throng.

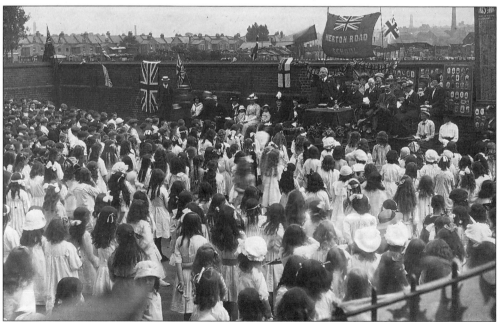

Merton Road School, now Riversdale School, during the First World War, with a display of photographs and a role of honour set up as a temporary war shrine; probably after 1917 as the US flag is displayed.

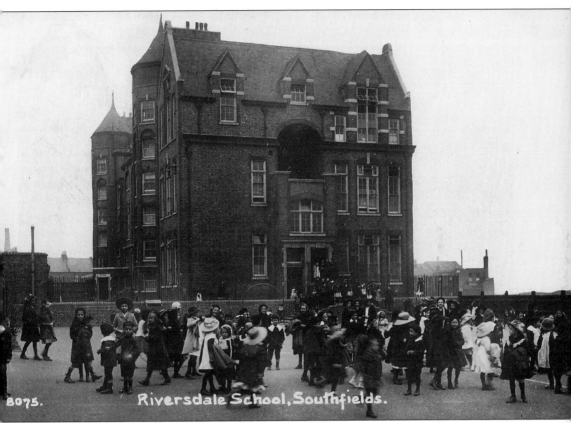

8075. Riversdale School, Southfields.

Merton Road School, on the corner of Replingham Road, had accommodation for 791 pupils when it was built in 1895, but it was enlarged to house a further 142 children. It is now called Riversdale School; the view here is of playtime, about 1910.

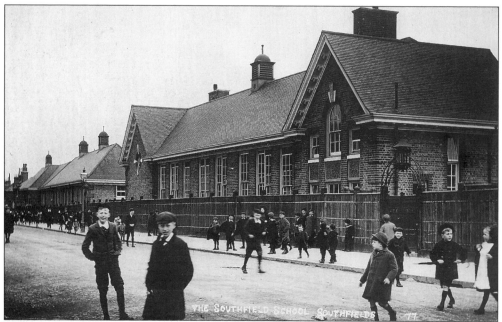

Southfields School, on the corner of Merton Road and Burr Road, seen here about 1910. Tenders were submitted by eighteen firms, but the one from Messrs J.M. Patrick at a cost of £19,419 and accommodating 980 pupils was accepted. The plans were later extended, however, to 1,126 pupils at an extra cost of £1,055. The building was designed by the Council architect, Mr Thomas J. Bailey, FRIBA. The school opened on Tuesday 9 May 1905.

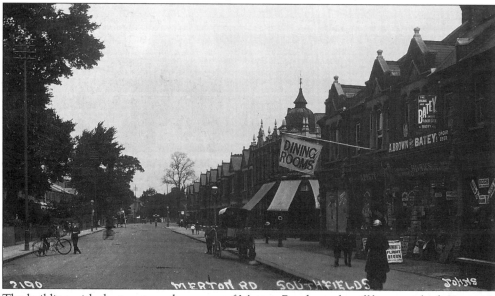

The building with the turret on the corner of Merton Road was the off licence which Young & Co. bought in 1969. They continued to run it as an off licence until 1974, when they converted that building and the one next door into a public house called the Pig and Whistle. The newspaper banner on the pavement announcing 'Beaumont's Flight Begun' was that of the Circuit of Britain Air Race won by the Frenchman Conneau on Wednesday 26 July 1911: a total of 1,010 miles over five days.

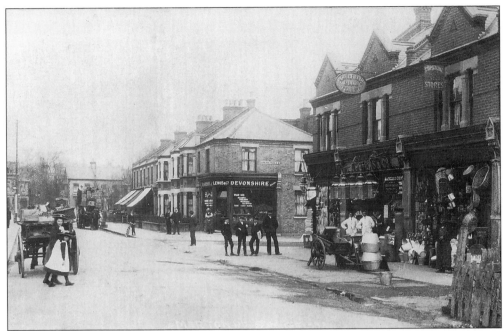

Merton Road at the corner of Camborne Road, 1906. The small parade of shops named Bexhill Terrace comprised the Ferdinand Upstone oilstores with a display that must have taken some time to assemble each day. Next to that was the gents' hairdressers, W. Peters & Co., with the staff in white standing by the entrance. The dairyman, in his blue and white striped apron, stands by the door of Lewis & Co. dairy.

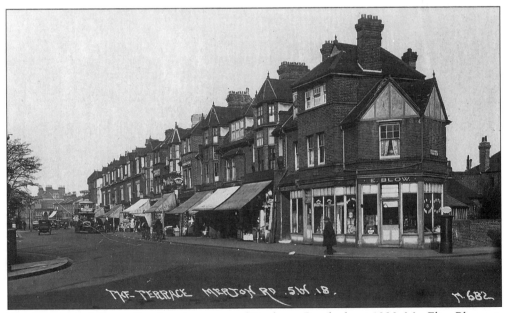

The Terrace in Merton Road at the corner of Brathway Road, about 1930. Mrs Eliza Blow ran the corner grocer's shop, and the terrace at the time included several butcher's shops, a fishmonger, a fruiterer, a greengrocer, and at numbers 9 and 2 the oil shops where, amazingly, a pair of oil jars above the shops' facias still, in 1994, survive in good condition.

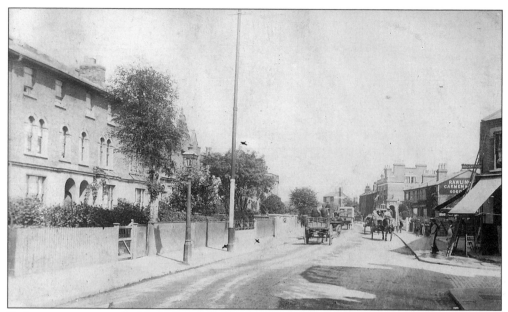

Early expansion out of Wandsworth comprised this row of houses on the left, which appear on maps of 1865; and the Lord Palmerston public house, on the right beyond the vehicles, also dates from this time. In this view from 1906, the Council had street names on the glass panels of the street lamps, the one on the left pointing to Coliston Road off to the right.

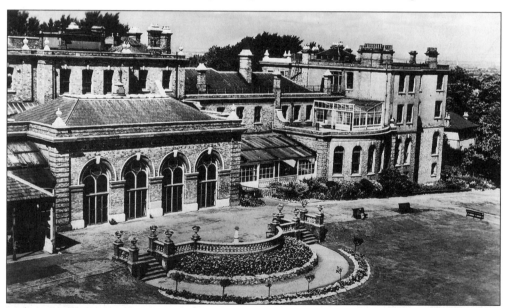

Melrose Hall, West Hill. First built for Lady Rivers in the eighteenth century, the Hall used to be called West Hill. It was rebuilt later on in the same century—as we see it today—by John Arthur Rucker. When on honeymoon, his son visited Sir Walter Scott at Melrose Hall in Roxburghshire; on his return he gave the name Melrose Hall to his West Hill residence. The next owner was the Duke of Sutherland, and it then passed to a Mr Beaumont who began to develop the adjacent area in the 1860s. The hospital took it over in 1864, and several additions have since been made.

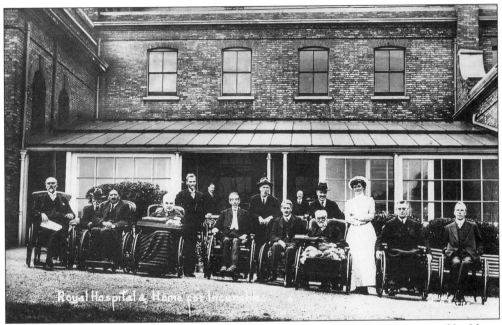

A nurse and patients (above) on the verandah appears in the centre of a group of buildings shown on the opposite page (bottom picture) dating from the 1930s. Also dating from 1910 is the view of the beautiful entrance hall to the main block (below).

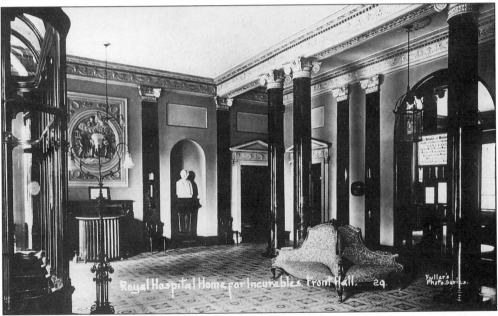

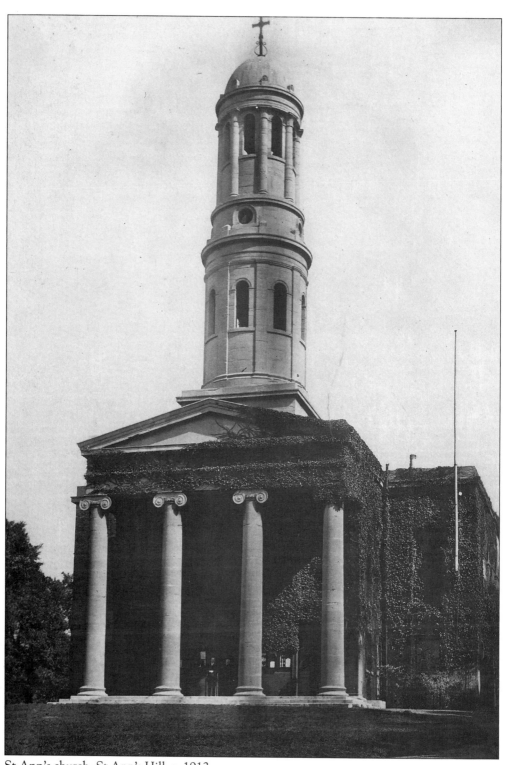

St Ann's church, St Ann's Hill, *c.* 1912.